Good Design

Good Design

Terry Marks *with* Matthew Porter

BEVERLY MASSACHUSETTS

Deconstructing Form and Function and What Makes Good Design Work •

ROCKPORT PUBLISHERS

First published in the United States of America by
Rockport Publishers, a member of
Quayside Publishing Group
100 Cummings Center
Suite 406-L
Beverly, Massachusetts 01915-6101
Telephone: (978) 282-9590
Fax: (978) 283-2742
www.rockpub.com

Library of Congress Cataloging-in-Publication Data
Marks, Terry.
 Good design : deconstructing form, function, and what makes design
work / Terry Marks with Matthew Porter.
 p. cm.
 Includes index.
 ISBN-13: 978-1-59253-529-3
 ISBN-10: 1-59253-529-1
 1. Design. I. Porter, Matthew. II. Title. III. Title: Deconstructing form,
function, and what makes design work.
 NK1510.M38 2009
 745.4--dc22

 2009001388
 CIP

ISBN-13: 978-1-59253-529-3
ISBN-10: 1-59253-529-1

Design: tmarks design
Layout and Production: *tabula rasa* graphic design
Photographs of the Eames Lounge Chair and Ottoman ©1956 (page 27, bottom)
and Eames Molded Plywood Lounge Chair ©1945 (page 127, right) courtesy of the
Eames Office, LLC, www.eamesoffice.com

Printed in China

This is a grand experiment and adventure, after all.

So dare greatly.

It may be the only way to live life to the fullest.

Contents

Introduction

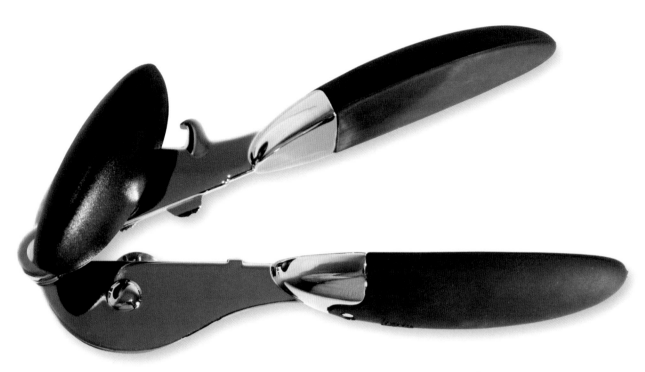

MICHAEL GRAVES' CAN OPENER FOR TARGET. BETTER OR JUST BETTER LOOKING?

IT DEPENDS ON YOUR DEFINITION OF "GOOD"

Why does the plain old-fashioned metal can opener still outsell the expensive and beautiful designer models? Is it cost? Is it superior functionality? Or is it the perception that design adds beauty without adding value? Perhaps designer enthusiasm overtook the justification of greater cost. Perhaps form overtook function. When function follows form, consumers rebel. Is there a magic space where form and function can coexist?

Design is everywhere—some even say design is everything. But with design touching so much of what we see and use, is it possible to distinguish good design from bad? Or purposeful design from useless, effective from ineffective? Is there an objective definition of good design? Why do some things capture our imagination

THE SLEEK DESIGN OF THE IMAC HAS CHANGED
THE WAY WE THINK ABOUT COMPUTERS.

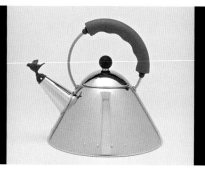

and attention? How can we objectively quantify or evaluate good design? What are its common characteristics?

This question cannot be answered by one omniscient being. But perhaps a panel of talented, experienced (and opinionated!) professionals can help lead us to a consensus on good design. That is what this book is all about.

We sought out some of the leading design practitioners from around the world and asked them their opinion on what makes design effective or ineffective. Through these dialogues, we discover common ground that can help us all measure and evaluate design in the world around us. Certainly these men and women all have their own perspectives, prejudices, and preferences. But, by and large, they agree on common characteristics of good design: concept, content, craft, surprise, suspense, and communicative efficacy. With this book, you will become privy to their thoughts on what makes some design stand above the crowd.

THE ONCE AND FOREVER UPS LOGO BY PAUL RAND. MANY HAVE QUESTIONED WHY IT NEEDED AN UPDATE WHEN THIS LOGO WAS SO GOOD.

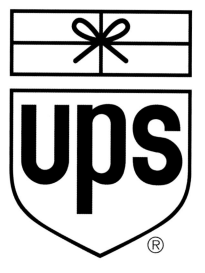

THESE BAR COASTERS, DESIGNED FOR AN ATTORNEY BY TMARKS DESIGN, ARE UNEXPECTEDLY ON TARGET AND MEMORABLE.

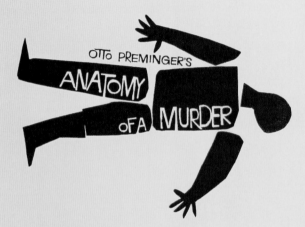

OTTO PREMINGER'S

ANATOMY OF A MURDER

STARRING
JAMES STEWART

LEE REMICK

BEN GAZZARA

ARTHUR O'CONNELL

EVE ARDEN

KATHRYN GRANT

and JOSEPH N. WELCH as Judge Weaver

MP490

SAUL BASS' *ANATOMY OF A MURDER* FILM POSTER. BASS' WORK IN FILM AND FILM POSTERS STILL INFLUENCES DESIGNS TODAY, MORE THAN FOUR DECADES LATER.

Good Design
In Practice

THE FOLLOWING CASE STUDIES DEMONSTRATE GOOD DESIGN IN PRACTICE. THE PROJECTS ARE APPROPRIATE FOR THEIR AUDIENCES, EASY TO UNDERSTAND YET CLEVER, AND, IN SOME CASES, OUTRIGHT HILARIOUS.

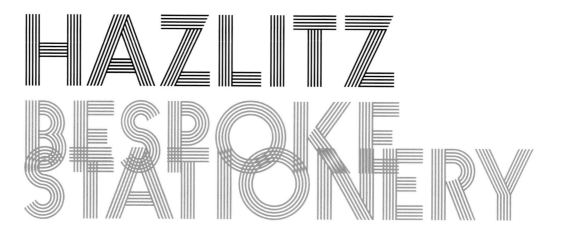

IDENTITY
HAZLITZ BESPOKE STATIONERY
BROWN DESIGN, LONDON

Hazlitz wanted to create a contemporary brand that would challenge the more established and stuffy stationers such as Smythson. To do this, the design would use traditional materials and print techniques applied to traditional elements such as business cards, letterhead, and so forth. But to stand out, it all had to be done with a twist yet still imply a level of personal, high-end service that Smythson was famous for. After all, the target audience was socially prominent, high-brow Londoners. The name Hazlitz was inspired by William Hazlitt, a prominent nineteenth-century English literary critic, grammarian, and philosopher.

The design is based on reams of paper and a complementary font. Letter-spacing, stroke density, and negative leading and tints were carefully prepared. The client liked the simple, pared back typographic approach common to premium brands. The designers established a black-and-white design and then focused on the quality of materials and print techniques such as engraving, embossing, debossing, and foiling items that their customers wouldn't sniff at.

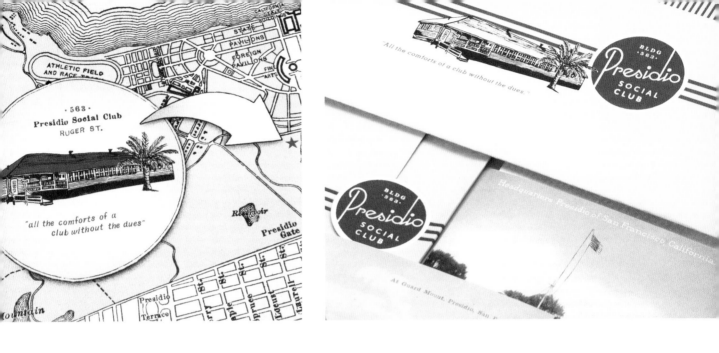

IDENTITY AND ENVIRONMENTAL DESIGN
PRESIDIO SOCIAL CLUB
MUCCA DESIGN, NEW YORK, NEW YORK

The Presidio Social Club is a restaurant housed in old military barracks at the heart of the historic Presidio military base in San Francisco that is now home to many businesses and organizations. The historic Presidio buildings are protected from external alterations or signage. The Presidio Social Club owners asked Mucca Design to create a compelling presence for their restaurant among the hundreds of identical, nondescript buildings. The concept was obvious: capture the mood of a pre–World War II American diner that would appeal to discerning San Francisco diners who are attracted to restaurants with warm, social atmospheres.

After extensive research, Mucca began to create a detailed fictional visual history using old photos as well as vintage drawings and maps that linked the new restaurant to the area's history. These storyboards were then used to recreate the warm atmosphere of a vintage social club, making customers feel comfortable as they lingered over drinks and good food. Custom 1940s-inspired typography was created and the building number, 563, is integrated into the design of the official typeface of Presidio Park. A rich, brick red color lends a feeling of heritage and complements the red roofs—a dominant architectural feature throughout the Presidio.

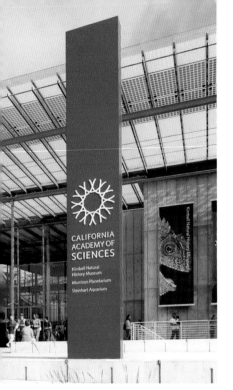

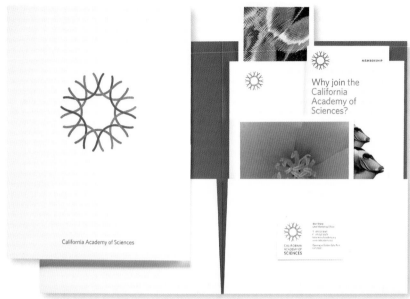

IDENTITY
CALIFORNIA ACADEMY OF SCIENCES
PENTAGRAM, SAN FRANCISCO

The 154-year–old California Academy of Sciences is located in Golden Gate Park in San Francisco. The academy hired architect Renzo Piano to create a single building that would unite the academy's principle elements: its aquarium, planetarium, natural history museum, three theaters, and four-story rainforest. Piano's solution reflects the academy's mission: "Explore, explain, and protect the natural world," and the building is now the largest Leadership in Energy and Environmental Design (LEED) Platinum building in existence. Enter Pentagram San Francisco headed by Kit Hinrichs to create an identity, signage, and marketing solution that lived up to the building and the academy's mission. First, designers looked at the building's construction: a "web of life" that includes a "living roof," an open-air piazza and a visible steel skeleton. To distinguish between the three principal elements of the facility—the aquarium, planetarium, and museum—different colors were selected for each. Material choices for signage and wayfinding (such as etched stone) reinforce the purpose of the facility and link it to the natural world. The result is an organic whole that showcases a beautiful facility with an important purpose in the life of San Francisco and its visitors.

IDENTITY
TIMES SQUARE ALLIANCE
THE OFFICE OF PAUL SAHRE, NEW YORK, NEW YORK

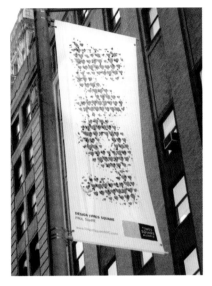

This banner was created by Paul Sahre for the Times Square Alliance, presumably to communicate the organization's efforts to make Times Square a safer, more livable, and family-oriented destination. Sahre, however, is well known for not letting viewers take his work at face value. Why this ultra-happy, pastel-laden, love-love banner for a district formerly known for porn theaters, crack dealers, and the faded lights of the Great White Way? Perhaps because the designer wanted to remind us that not everyone thinks the sanitized, family-friendly Broadway district is for everyone. This banner simply reminds us that not everyone loves *The Lion King* and *Aladdin* 365/24/7. In this book, Sahre reminds us that "good" and "bad" are useless definitions without context.

IDENTITY
BRAINCANDY
TURNSTYLE STUDIO, SEATTLE, WASHINGTON

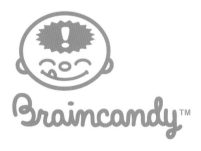

Braincandy creates developmental DVDs, CDs, books, and toys designed to help young children think critically, creatively, and independently. The first set of products focuses on exploratory learning through use of the five senses. The logo and accompanying icons utilize *kawaii*, or cute style, by adopting the look of Japanese animated cartoons ubiquitous in that country. The logo communicates the idea that learning can be yummy to the mind. The icons are animated on DVDs. Simple, direct, and intuitive, the symbols communicate the critical message to the critical audience—kids and parents—that learning is fun, the content is approachable, and the purpose is serious. Yes, this is a product for kids, but it doesn't need to talk down to them. Company owners liked the Braincandy design so much, they tattooed it onto their bodies. They would not say where.

PACKAGING

GLORIA PUBLISHING

HENRIK PERSSON, STOCKHOLM, SWEDEN

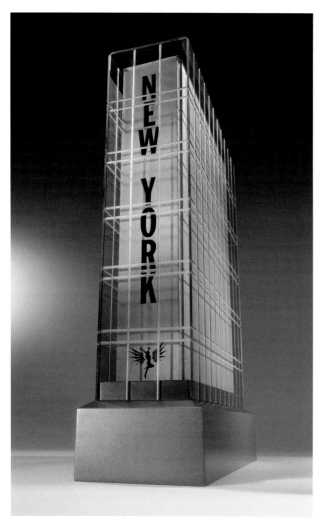

Gloria—one of the world's finest luxury big-book publishers—was producing a "must-have item" for those interested in modern history, architecture, and photography. All of their books aim to be the ultimate statement on whatever subjects the book is about (i.e., you would never ever have to buy another book on the same subject again). The two-page brief said to make it "The greatest book about the greatest city." Only wealthy book buyers or avid collectors would purchase these books. The concept was to take New York City's grand and vertically impressive architectural landscape and make it a book. But instead of using an image to communicate the idea, designer Henrik Persson decided to stand the 756-page, 35-pound (16 kg) book upright and encase it in a Perspex box that mimicked a skyscraper. Golden silk suggests metal. The book sits in a bronze-colored base that adds to its monumentality. *Voilà!*—the book becomes architecture.

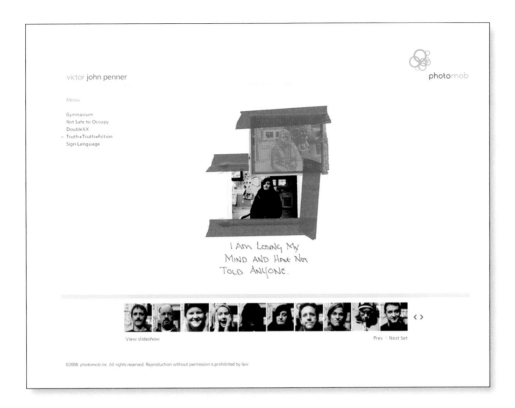

WEBSITE

PHOTOMOB

TURNSTYLE STUDIO, SEATTLE, WASHINGTON

Photomob is a portfolio site for photographer Victor John Penner and is an assignment-based photography service that standardizes and streamlines the photography-buying experience. Buyers select a photographer from the Photomob roster that is well suited for their assignment objectives and location. Photomob then handles all the production logistics for the shoot. The symbol represents the diverse roster of Photomob photographers. This solution was a true collaboration with client photographer Penner. First, Penner secured an attention-grabbing name that lends the site some presence. The target audience is art directors, designers, and other creative people, so a well-crafted design solution had to set the stage for Penner's images. But this means that the design had to be simple and transparent, letting the photography speak for itself. The site features "true confessions" mixed with random Polaroid portraits of individuals—part of a workshop the photographer conducted. It's memorable because it's humorous and twisted. In this case, client and design took a "more is more" approach: There's a lot of work on this site, too.

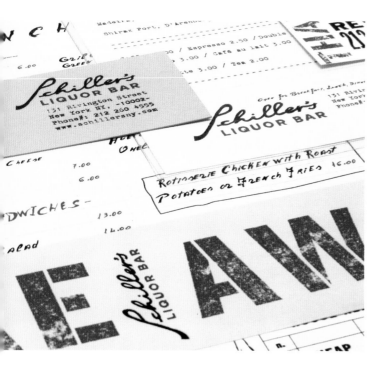

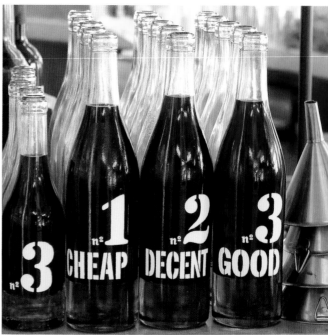

PACKAGING
SCHILLER'S LIQUOR BAR
MUCCA DESIGN, NEW YORK, NEW YORK

Schiller's is located in the recently gentrified historic Lower East Side of Manhattan. To capture the old spirit of this neighborhood—once dominated by hardworking new immigrants, factories, and tenement living—Schiller's wanted the look to appear as undesigned as possible, as though a local couple had opened the place to draw in young New Yorkers from across the city—people who could afford very nice martinis. One day at a client meeting, the team looked at an old French bottle with the number 1 scripted on the label. The group began to joke that a rating system would allow people to choose the quality level they desired (or could afford). Creative director Matteo Bologna says, "We first suggested the ratings Bad, Decent, and Expensive, but my client canned that idea." The client found beautiful blue glass bottles reminiscent of old milk bottles to convey a sense of history and reinforce artisanal/local feel. The bottles were then silk-screened to add patina to the look. What this has to do with immigration is anybody's guess. But even Lower East Side financiers enjoy a cheap, decent, or good stiff drink now and then.

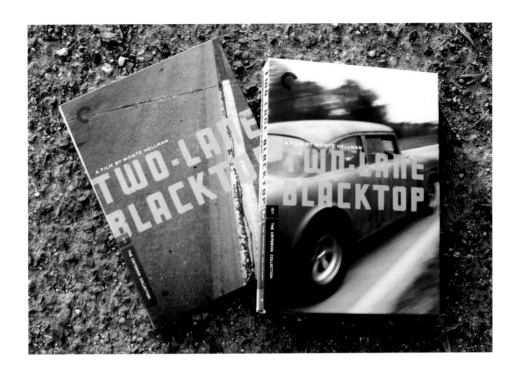

PACKAGING
CRITERION FILM COLLECTION
MARC ENGLISH DESIGN, AUSTIN, TEXAS

Criterion Collection packages and distributes classic and contemporary films on DVD for some of the finest filmmakers and films in the world. They expect the package design to contribute to the overall experience of the film, moving product that's all about dreams and storytelling. The audience is cineastes, film geeks, and plain old film fans. The designers watched this film several times, paying attention to the mise-en-scène, the film's visual style and design—such as building signage, background posters, clothing, sets, and props. *Two-Lane Blacktop* captures America at a crossroads—the end of the 1960s and the beginning of the 1970s.

The design showcases the culture of America's back roads: dirt roads; riding hot and heavy, day and night; watching shadows grow and fade from California to Mississippi. The covers—both type and image—are simple, though not identical. The DVD cover is a shot of blacktop that has yellow road striping overlapping older white striping. The client preferred the '56 Chevy as the entire package slip case—a metaphorical vehicle for moving characters and story across the country.

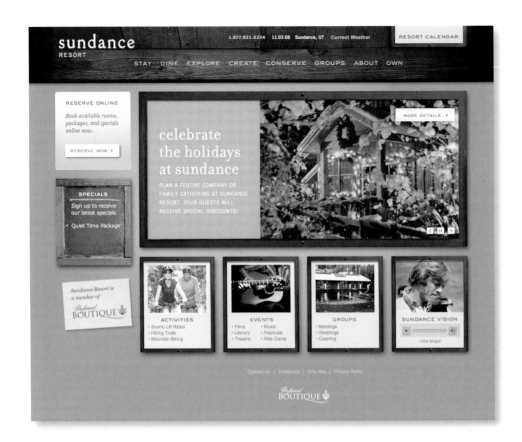

WEBSITE

SUNDANCE RESORT

ADAMSMORIOKA, BEVERLY HILLS, CALIFORNIA

Sundance Resort wanted to increase its reservation volume and better present the range of activities it offers. As part of Robert Redford's Sundance family of companies, the resort's heritage needed to be more central to the site narrative. The client's message was to show why the Sundance experience is not a typical five-star resort. Its authentic connection to the natural world appeals to outdoor enthusiasts, families, ecotourists, Sundance Film Festival attendees, as well as meeting and event organizers. Design focused on the resort's sense of place by using real objects such as frames and weathered paper to hold imagery and messages. Landing pages integrate sound and quiet animations with panoramic imagery. Colors were derived from the resort's authentic interior and exterior environment.

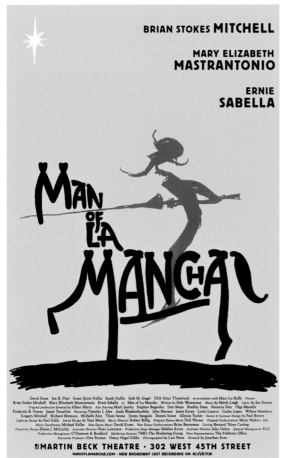

Gail Anderson was asked to create a poster and advertising for a new Broadway production of *Man of La Mancha* for producer David Stone in 2002, not long after she started at SpotCo. The average ticket buyers are affluent women and in their 40s and 50s. The play's producers wanted something iconic, not photographic, and wanted to pay homage to the show's original art. Anderson started first with type that became a donkey. Next, she placed Quixote on top. After several more attempts, the art began to take shape. Next, colleagues James Victore, Ward Schumaker, and Laurie Rosenwald pitched in to improve upon Anderson's rough sketches. The client was shown two ideas and immediately asked to combine principal aspects of both. Anderson feared a Frankenstein.

She recalls, "Much was made of the poor horse's tail and ears. Up? Down? Higher? Lower? Which way should the lance point? Where would the actors' names sit? Where should the star go? I'd never worked that way before, with people focusing on every little detail like that, so I was a little taken aback by the whole process. But in the end, we'd created a nice icon that we were all proud of. It's still one of my favorites, because creating an icon is so difficult; everyone wants the *Phantom* mask or the *Cats* eyes or the *Miss Saigon* helicopter, and it's so hard to boil a show down to one element. I don't think I've done one like *La Mancha* since, or at least not one that's ever been chosen."

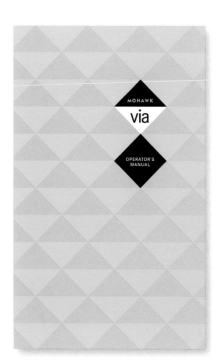

PRINT

MOHAWK VIA

ADAMSMORIOKA, BEVERLY HILLS, CALIFORNIA

Mohawk needed to revitalize its Via paper line. The directive was to reinforce Mohawk's reputation as a leader in the design community and in the practice of sustainability. Via is a value-based paper of fine quality, versatility, and variety for "everyday" use. The audience is chiefly designers, art directors, printers, and paper merchants. The design concept focused on Via's demonstrable print quality and versatility. To tell the everyday story, designers used materials such as khaki fabric that are both casual and honest. To make the promotions more ecofriendly, they also had to be useful: The books are learning tools—textbooks on paper and printing. They are designed to be open on a designer's desk and used as a reference tool. The operator's manual features a light touch of Hawaii-ana to give everyone a moment of a "holiday" in the midst of the economic crisis of the times.

The Designers at Large

Kit Hinrichs

Partner, Pentagram

San Francisco, California, USA

Kit Hinrichs is the legendary spirit and leader behind Pentagram's San Francisco office. He is a familiar, avuncular presence at design gatherings all over the world. Hinrichs' success has never gone to his head, even if many keep trying to foist him onto a pedestal. His intelligence, talent, and accomplishments are matched only by his kindness, generosity, and approachability. He knows people call him Santa Kit, not only for his well-groomed white beard and embraceable stature, but because of the joy and good fellowship he brings to the world of design.

KIT, YOU ARE AN AVID STUDENT OF DESIGN HISTORY. NAME A FEW OF THE LEGENDARY INNOVATORS IN DESIGN WHOM YOU ADMIRE MOST.

First, let me say that I am fortunate to work in a rarefied world with some of the most talented people in design practice today. So when you ask me who influences me or to whom I look for inspiration, I would have to include all of them on my list. But I'm at the upper end of the age scale, so a lot of the people who have influenced me were not my peers and friends. Forty years ago, when I was starting out, I had my own list of heroes, Ivan Chermayeff and Tom Geismar among them, for example. Here were two guys whose work changed the face of design in corporate America and even with some sectors of U.S. government. No team was better able to synthesize a number of ideas down to a single symbol. They were and are magnificent.

"IT WAS NOT SIMPLY THAT THEIR WORK LOOKED PRETTY, IT
WAS THAT THEIR WORK COMMUNICATED ON AN EMOTIONAL LEVEL.
THIS IS THE BEST KIND OF DESIGN COMMUNICATIONS."

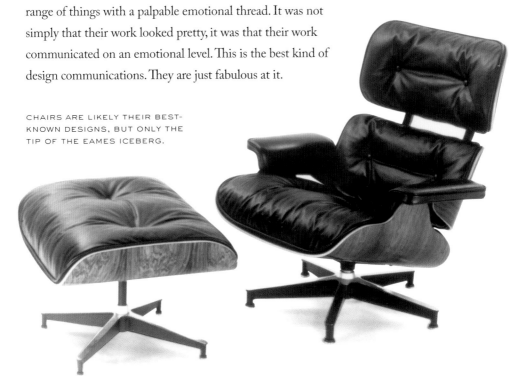

I also care a great deal about the legacy of Charles and Ray Eames. I kind of grew up in their times and I witnessed any number of their exhibitions. They fascinated me.

And because I'm the kind of person who likes a lot of things, the idea of storytelling using so many different elements and disciplines was something that really got to me. Charles and Ray were unbelievably gifted in their storytelling ability. Their exhibitions would combine a whole range of things with a palpable emotional thread. It was not simply that their work looked pretty, it was that their work communicated on an emotional level. This is the best kind of design communications. They are just fabulous at it.

CHAIRS ARE LIKELY THEIR BEST-KNOWN DESIGNS, BUT ONLY THE TIP OF THE EAMES ICEBERG.

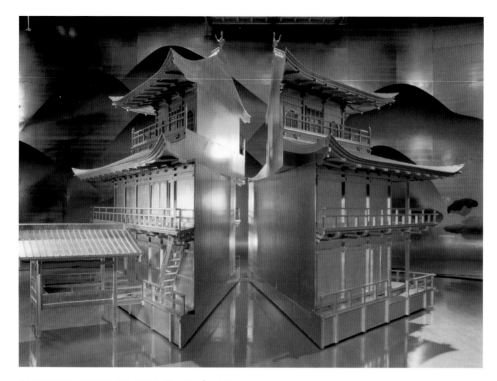

ABOVE AND OPPOSITE: EIKO ISHIOKA'S COSTUME AND SET DESIGN FOR THE FALL AND THE GOLDEN PAVILLION.

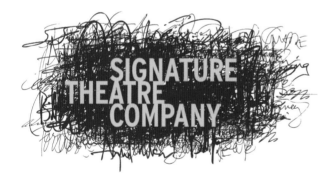

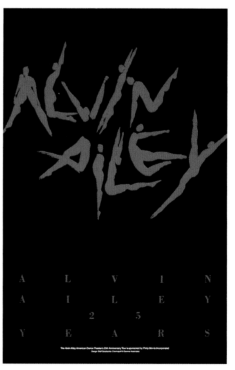

ABOVE AND RIGHT:
C&G PARTNERS DESIGN
FOR SIGNATURE THEATRE
COMPANY AND ALVIN AILEY

If you saw the opening ceremonies of the 2008 Beijing Olympic Games, you saw the work of Eiko Ishioka, an extremely gifted designer from Japan who has been doing great work forever. She has done costumes for films such as *Dracula*, for instance. She's done unbelievable promotional campaigns and programs at home, but she works everywhere. I was so pleased to see her involved in the opening ceremonies.

How about here in the states? Whose work today grabs your attention time after time?

Stefan Sagmeister continues to break new design ground through experimentation and risk taking. Some of his most recent typographic experimentation just knocks my socks off. I once interviewed him for a job here, and I told him to go back to New York and do his own thing, because it was clear to me that he was a special individual. Years later, we bumped into one another at some event and he said, "See? It was a good idea." I take full credit for Stefan's success as an independent professional. I am kidding, of course.

Anyone else?

I invite readers to also study the terrific work of Steff Geissbuhler at C&G Partners in New York. Steff is one of those guys whose design is classical. They are never trendy. It is fresh a year from now. Five years from now. Or ten, twenty years from now. Steff and his group create good design that can speak to a broad range of people for a very long time— two hallmarks of great design.

What makes good—or great—design compelling?

As I said earlier in regards to the work of Charles and Ray Eames: emotional content, storytelling ability, and staying power. These are the three criteria of great design. If you do not have an emotional (or intellectual) link between content and audience, you're talking to air. Your effort is wasted.

You have spoken before about design for your family. What do you mean by that?

Design isn't just about winning awards and making your peers happy. It also is about doing things that communicate to your family. I'm not saying I'm always designing for my sister, but I think that design done well is easy to understand and connects on an emotional level. It may reflect different degrees of sophistication in its execution—it may employ a very talented illustrator, great photographs, or nice typography—but you do not get in between the message and audience, between you and your sister. That's very important to me.

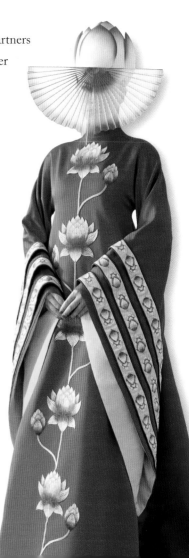

You have been doing this a long time. So what keeps you coming back to the office every day, Kit?

To a certain extent it is simply this: I have a job that I love to do, that I'm not bad at, and that I can do every day for the rest of my life. When I'm not intellectually satisfied by my work, I have no one to blame but me. I am very fortunate to have the opportunity to work all around the world, meeting all kinds of people, learning about their lives, businesses, institutions, and cultures. Mine is a unique gift that I was given.

What is the ultimate responsibility of good design?

Everything we do that fails, subtracts rather than adds to the value of our culture, then degrades our culture. You cannot be neutral. You cannot say, "Oh, it's only a newspaper ad," or "It's only going to be used for fifteen minutes, don't worry about it."

What kind of reference and source materials do you look to for ideas and inspiration?

Forty years ago, I looked at every design magazine out there. Thank goodness I'm past that. I'm an observer. I get true inspiration from the world around us. From the culture we're in. I think at some point you have to get beyond being self-referential, not be too immersed in your own professional culture. Get out and find what is real.

ABOVE, RIGHT AND OPPOSITE: KIT HINRICHS' OWN WORK IS FOUND EVERYWHERE DESIGN IS CANONIZED. NOTE HIS LOVE FOR OLD GLORY.

THIS BOOK IS ABOUT DEFINING GOOD DESIGN. BUT AT YOUR LEVEL, YOU OFTEN ENCOUNTER "THE GREAT." DISTINGUISH BETWEEN THE TWO FOR US.
We are a product of our culture. What we find interesting or humorous—what communicates with us—depends upon the culture we are part of. Great design transcends the limits of culture. I have looked at design in Japan, Russia, and China and said to myself, "That is a beautiful piece of design," based upon its aesthetics. I may not fully understand what it's about but I can understand enough. I can decipher part of the message. When you can transcend the limitations of your own culture to effectively communicate to people in others, you have something very special. Great design achieves this.

AT THIS STAGE IN YOUR CAREER, DO YOU STILL HAVE SOME ASPIRATIONS TO FULFILL?
I never tire of telling stories. I hope that I have been and will continue to be a good story-teller. On a more fanciful note, I would have liked to design a World's Fair Exposition—but they don't do them anymore. If they still did and they hired me to do it, I would lead people around using all the senses, all the tools design has to offer. It would be the most interdisciplinary design experience ever imagined. But of course, I'd hire a good architect to make sure the whole thing stood up.

INTERVIEW:

Robynne Raye
Partner, Modern Dog
Seattle, Washington, USA

Robynne Raye is one half of the twenty-plus-year partnership called Modern Dog, a Seattle-based design studio noted for its often blistering, hilarious, and shocking creative product. When Raye talks about good design and what it takes to make it, she has a long legacy of evidence in her portfolio to prove she knows what she is talking about. Raye and business partner Mike Strassburger know their place in American design, but they are not boastful about it. They have a strong, distinct voice and the skills to project it. Confidence buys you freedom to be yourself—even when that self can be a very bad boy or girl.

ROBYNNE, WHOSE WORK DO YOU CONSIDER TO BE GOOD AND WHY?
I like work with soul, and here are a few that have it: Marian Bantjes, Alex Trochut, Rick Valicenti, Zeloot, Vito Costarella, and Sister Corita Kent.

YOUR WORK OFTEN HAS A RAW, UNFINISHED, HANDMADE QUALITY. IT APPEARS TO BE SPONTANEOUS. DO YOU JUDGE ALL DESIGN BY YOUR OWN STANDARDS?
Of course not. That would make for a boring world. For example, my partner Mike cannot stand slick design when it's polished and predictable for no good reason. It's soulless. I, on the other hand, am more receptive to a well-crafted piece, even if it is not necessarily what I would do. Look at the work of Rick Valicenti: He does not roll over for the client. I can see and hear his voice in his work, and that is why I regard it as exceptional. I also believe good design has to be appropriate.

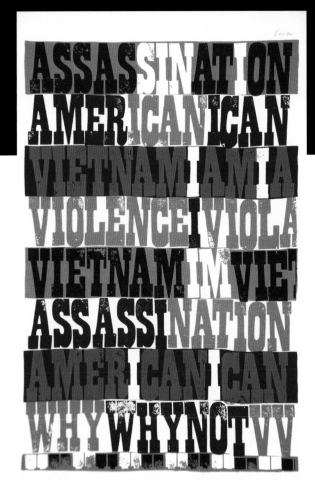

When ancestral kings corrupted their captains, and the church blessed both captains and kings the court jester got laughs simply by sniffing the troubled air, implying that the sting in the herring begins in its head. In our times, it isn't surprising to find men and women crowding the night clubs in hopes of seeing someone sniff the air.

In such times clowns become witnesses.

SISTER CORITA KENT'S WORK IS WELL AHEAD OF HER TIME. MELDING DESIGN, TYPE, AND SOCIAL ISSUES IS STILL RELEVANT TODAY.

WHEN IS IT INAPPROPRIATE TO INSERT A PERSONAL VOICE INTO THE WORK?

It has to fit a need. I don't want to see or hear the designer's voice in a Bank of America identity or on a medication label from my vet. But when I ask myself what kind of design compels me, it is most often where it is possible and appropriate to see and hear the designer's voice. Book covers, posters, invitations, websites, and so on are just a few of the projects that can have a distinctive voice.

YOU OFTEN PUSH LIMITS WITH HUMOR AND EVEN POLEMIC. WHEN DOES HUMOR OR BEAUTY DETRACT FROM GOOD DESIGN?

Again, when it's not appropriate. Many think the work we do for Blue Q is just about being funny or gross. But here's the truth: Blue Q is a successful multimillion-dollar

business. And our client, Mitch Nash, has been doing it for over twenty years. A lot of marketing strategy goes into every product. We make commissions on all of our Blue Q jobs, so it's in our best interest to scrutinize every minute design detail. We are especially critical of our copy. We want the consumer to be entertained with the product on every possible level. You think Phallic Produce magnets weren't a highly strategic and conceptual solution? Think again.

DO YOU BELIEVE GOOD DESIGN SHOULD BE CROSS-DISCIPLINARY?
I think a designer should know as much as they can. It has become a trend to say: I'm a designer, educator, artist, writer, typographer, movie producer, film score composer, screenwriter, exhibition designer, mustache trimmer, hydroplane racer, hot air balloonist, freestylist, captain of a fishing boat, elephant trainer, contortionist, chimney sweep, ancient Chinese calligrapher, and knob polisher. For example, Rob here at Modern Dog does his own plumbing. Shogo is a Japanese culinary artist, and Mike can make fart noises from behind his knees. We are people who design. We are Designers.

HOW DO YOU EVALUATE GOOD DESIGN—YOURS OR ANYONE ELSE'S?
You must constantly ask yourself, "Am I proud to say I did this work? Did I help my client achieve his or her goal? Did I make some money on it?" There aren't any steadfast rules, but generally speaking, poorly performing design lacks focus and direction. Good design is the opposite, often working in the most simplistic of ways. Design is bad when it's inappropriate for the client's customers.

MARIAN BANTJES IS RENOWNED FOR HER POWERFUL USE OF TYPE. *DESIGN IGNITES* SEEMS ALMOST LIKE NEEDLEPOINT.

Do you believe eye candy has a role to play in good design?
Pretty, visually pleasing design has its place where it is appropriate. It can also have a strategic role. Cosmetic packaging, apparel, menus, wine labels, book cover design, clothing labels—are often all about pretty. But in these types of design, even aesthetics are employed to evoke a mood, inspire a fantasy.

"Paul Rand said, 'Ninety-nine percent of all design is intuitive.' He was right. I can't explain what makes design good, but it's not like we don't think about what we're doing. Every detail is analyzed and thought out. Everything matters."

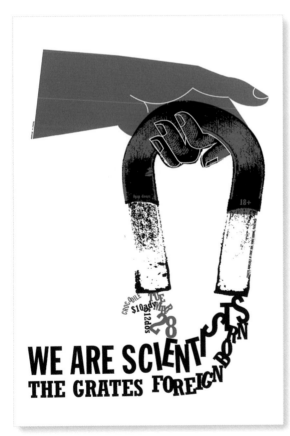

VITO COSTARELLA'S POSTER FOR WE ARE SCIENTISTS

RICK VALICENTI'S WORK IS ALMOST ALWAYS RECOGNIZABLE AS HIS OWN.

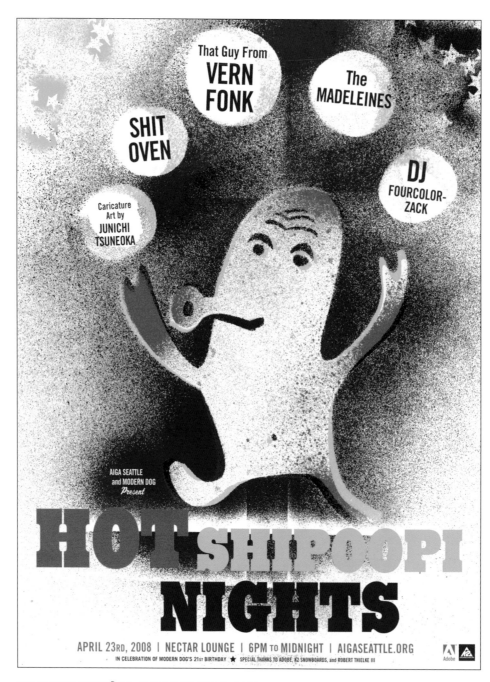

DID IT MAKE MONEY? NO, BUT THE BOOK DID. POSTER BY MODERN DOG FOR AIGA SEATTLE PARTY HONORING THE RELEASE OF A BOOK CELEBRATING MODERN DOG'S TWENTIETH ANNIVERSARY.

"B" is for Bunny.

"O" is for Ostrich.

ABOVE: THESE CHARACTERS, CREATED BY MODERN DOG FOR A JAPANESE CLOTHING LINE, MORPH INTO AN ALPHABET.

BELOW: "BLUE Q'S MITCH NASH HAS A VISION FOR HIS PRODUCTS. HE WORKS CLOSELY WITH THE DESIGNERS HE HIRES TO MAKE SURE THE DESIGN CLEARLY COMMUNICATES HIS GOALS FOR THE PRODUCTS."

Atsuki Kikuchi
Bluemark
Tokyo, Japan

Atsuki Kikuchi and **Toshihiro Saito** founded Tokyo's renowned Blue-mark, a branding and web design firm. Talk about precocious: Kikuchi was still studying at Musashino Art University when he started his first design venture, Neo Standard Graphics. From 1997 to 1998, he co-managed the alternative art space, Studio Shokudo, before cofounding Bluemark in 2000. Bluemark is a virtuoso talent across a broad range of disciplines, including housewares, fabrics, corporate identity, print graphics, and exhibition design. Kikuchi and his colleagues at Bluemark can speak any language they desire. It is their work that is making a worldwide statement.

ATSUKI, WOULD YOU TELL US WHO INSPIRES AND INFORMS YOUR WORK?
Akira Minagawa, a fashion/fabric designer for Mina Perhonen, brings a lyrical quality to real-world objects. Issey Kitagawa, art director and designer at Graph, stands out through his use of subtle—and sometimes mysterious—details that are not readily detectable. It creates an aura around it, like a supernatural force that catches the eye. In good design, such subtlety and oddity makes for a strong and lasting experience.

Another group I admire is Vier5, a Paris-based team of graphic designers noted for their radical direction (spare, ornament-free). They created Fairy Tale magazine and the signage for the Documenta 12. They unite the visual worlds of digital and analog in surprising ways.

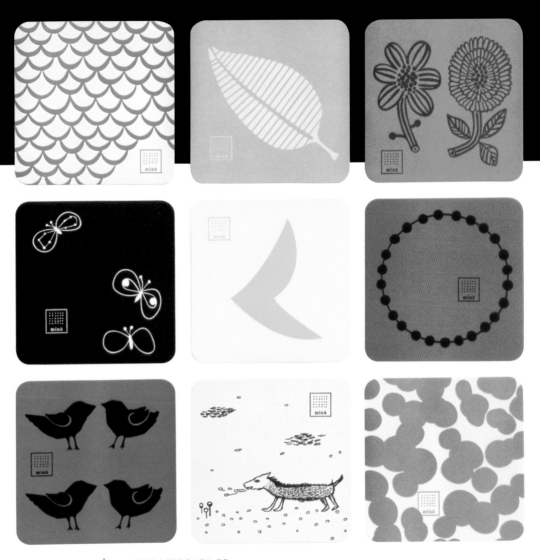

MINA PERHONEN'S UNIQUE APPROACH TO
PATTERN AND DESIGN MAKES EVEN PEDESTRIAN
ITEMS, LIKE THESE COASTERS, COVETABLE.

WHAT MOTIVATES YOU TO MAKE YOUR WORK BETTER?

I am inspired and motivated by history. When I see something from the past that captures my attention, I am motivated to make my mark on the future by creating something today that lasts for the ages.

WHAT IS THE VALUE IN CROSSING DISCIPLINES IN GOOD DESIGN?
The essence of good design lies not in the arrangement of objects on a surface but in a way of thinking and approaching a design challenge. Yes, it is possible (and possibly advantageous) for a designer to use other disciplines when trying to respond to a particular client challenge. But it is critical that their response has substance: Every discipline requires tremendous skill—acquired skill—so one should be aware that exercising other disciplines is not for the novice. It is a very difficult thing to accomplish.

"GOOD DESIGN DISPLAYS THE OBVIOUS WITHOUT BEING THE MOST OBVIOUS. FIRST, LOOK FOR THE OBVIOUS SOLUTION. NEXT, LOOK BEHIND IT. HERE YOU WILL FIND THE LESS OBVIOUS, AN ELEMENT OF MYSTERY. GOOD DESIGN ADHERES TO THE FUNDAMENTAL PRINCIPLES OF ANGLE, SIZE, COLOR, AND LINE DRAWING. FOLLOW THOSE PRINCIPLES. THEN GO BEYOND THEM".

CAN YOU DEFINE GOOD DESIGN? CAN YOU OBJECTIVELY EVALUATE IT?
Good design should go beyond pure function. It should have justification for every element, every aspect of its appearance or aesthetic. If a designer adds a design element simply to create depth or movement within his composition, that is reason enough. That element does not have to have a function beyond creating visual appeal or emphasis.

HOW DO YOU VALUE AESTHETICS OR BEAUTY IN GOOD DESIGN?
Sometimes, beautiful form is the content. Pleasing or pretty design has its place because there is content that cannot be explained through language. It can only be articulated through the visual, through appearance, or through beauty.

WHERE DO YOU FIND INSPIRATION AND MOTIVATION TO FIND THE BEST
DESIGN SOLUTION?

Intellectually and emotionally, I take inspiration from many sources, modern art and
literature, for example. I also gain much insight and inspiration from my friends who are
artists, designers, and musicians. They help me find out who I am and they help me go
beyond myself. In Zen practice (which I study but do not practice), you are to discover
who you are now, what your desires and fears are now, and then you are to shed yourself of
all those definitions in order to become one with nothingness. If you do not throw away
your old or existing beliefs and convictions, you are unable to create anything new.

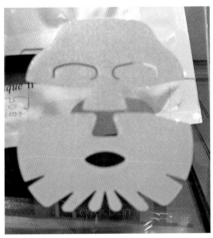

ABOVE AND ABOVE LEFT: ATSUKI KIKUCHI'S
OWN WORK FOR NATIONAL BRANDS DEFIES
STANDARD THOUGHT AND CHALLENGES THE
VIEWER TO FIND CONTENT WITHIN THE OVER-
ALL FORM.

LEFT: THIS IS SOME KIND OF COSMETIC BEAUTY
MASK THAT LOOKS AS IF IT WAS DESIGNED BY A
PRIMITIVE CULTURE. IT IS AN EXAMPLE OF GREAT
SCULPTING.

SQUARE PAINT BUCKET

NICK JONES, BROWNS DESIGN

My thoughts would be that anything designed to make decorating a less messy process is a good thing. Unfortunately, I have not seen or used the product and cannot vouch for its efficacy. Paint has a habit of not doing what it is told, so you are still going to get it dribbling down the outside of the spout. If the efficacy of the design is not 100 percent, then it is little more than a gimmick. For me, the design should come into the product itself. What chemicals are in the paint? What are the manufacturing processes involved? How much of an impact does it have on the environment and how can it be reduced? What chemicals are needed to clean up brushes, rollers, and so forth? At the moment, it seems many companies are manufacturing another piece of plastic for a promised reduction in mess. It is like supermarkets in the UK putting plastic packaging around oranges and bananas, which seems ludicrous to me given that they are two examples of great packing already.

JOSH HIGGINS

First of all, I can't believe that every paint company does not use these. They are so great! I love the fact that someone took it upon himself or herself to shake up the status quo in the paint industry and come up with something so simple and sensible. It's one of those innovations where you say to yourself, "Duh, why haven't they had these all along?"

There are so many advantages to this container: its spill resistance, its drain-trough recovery, its screw top, its molded handgrip, its no-rust and no-corrosion plastic. These enhancements surpass conventional paint container wisdom. The use of plastic transforms a paint container to an eye-appealing and practical alternative.

GAIL ANDERSON, SpotCo

Why didn't someone think of this before? I remember first seeing something similar made just for us gals. I guess the thinking was our Olive Oyl arms couldn't lift a regular can. But, kidding aside, this container makes total sense. Those metal cans are heavy, and the thin wire handles aren't suited for directing paint into the tray. I paid my super to paint my apartment recently, but if I had tried to do it myself, I'd have looked for paint that comes in nonspill plastic containers like this one. Also, I'm a delicate flower, and only my big, strong super can deal with those awkward cans.

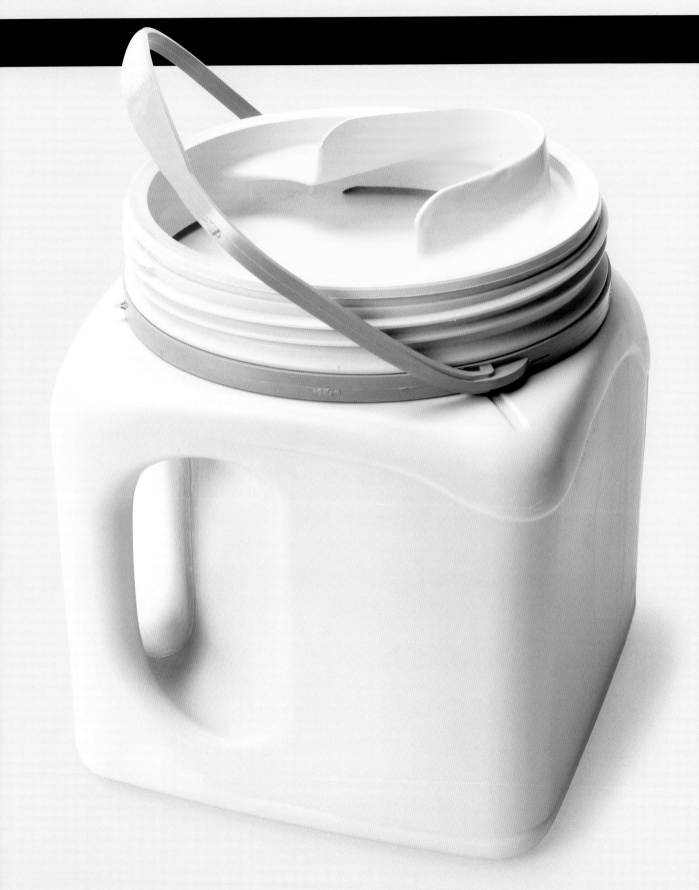

99 PERCENT INTUITION

Here's the reminder so many of our contributors have themselves implemented: Unplug your iPod, put down your iPhone/Crackberry, and take at look at the world around you. If you don't, you might be missing life's critical content. It's free inspiration. We take things seriously that we should probably ignore. We ignore too much that is important.

Our talk is peppered with knowing remarks about typeface choices and the mention of iconic names as if they were our own Uncle Eames. Sometimes, we are all guilty of trying so hard to be outside that we get stuck inside ourselves. Not a horrible place, but it can be lonely.

We should be wary of becoming cartoon images fit for the Simpsons but not for the truth. All the "exclusivity." Isn't it a little much? The only Parthenon of design is the Parthenon.

When I was young, I wanted nothing to do with design organizations. Revealing more about my own sense of self-worth and vanity, I viewed them as back-slapping clubs. I learned later that they were more. They were also places where like-minded people could gather and do some good for their communities—and themselves.

So take a deep breath. Get your focus back. Exercise your body and not just your creativity. Think about something other than design. Focus on things that inform, guide, or inspire you. Discover something new to you. Pull the buds out of your ears, take your fingers off the keypads, and lift your eyes from your navel. Good design will follow. As Uncle Rand observed, "Design is 99 percent intuitive."

But intuition requires knowledge, and knowledge requires experience beyond the four corners of your computer screen.

Art Chantry is an icon in modern poster design. His work spans decades and influences several generations of designers. He is alive and well today, living in Tacoma. From the outside, he might be seen as the prickly, grumpy Harvey Pekar of graphic design. In person, he is gentle but highly opinionated. He brooks no fools. Indefatigable, he is still in pursuit of great work.

ART, SHARE WITH OUR READERS THE NAMES AND EXAMPLES OF SOME DESIGNERS WHOSE WORK HAS MADE A POWERFUL IMPACT ON YOUR CAREER.
There are a lot of good designers. I could make a list that would fill a page, but most of them are people you likely never heard of: Harry Chester, Cal Schenkel, Franko (Frank Edie). These people work on the fringes of popular design. They are part of the design underground.

Cal Schenkel I found at a delicate point in my creative development: the eighth grade. I had just been freaked out witnessing events of the 1968 Democratic Convention in Chicago. I saw Dan Rather getting beat up on TV. Soon after, I attended my first antiwar rally, where I met other students who would soon expose me to music other than what I knew from the radio. I soon purchased my first Frank Zappa album, *Uncle Meat*, and Captain Beefheart's *Trout Mask Replica*, both designed by Cal Schenkel. I was never the same again.

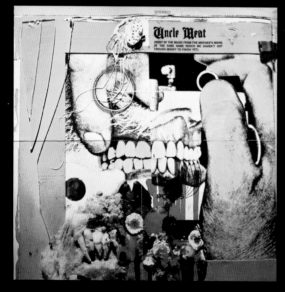

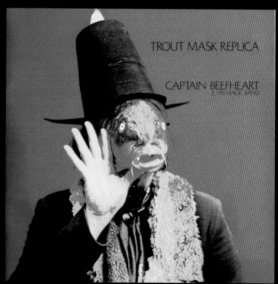

TOP AND ABOVE RIGHT: CAL SCHENKEL'S DESIGN FOR FRANK ZAPPA'S *UNCLE MEAT*.

ABOVE LEFT: CAL SCHENKEL'S *TROUT MASK REPLICA*.

WHAT MADE YOU RESPOND TO HIS WORK? WHY DO YOU THINK IT IS SO GOOD?

At that moment in my life, Schenkel's work was honest-to-God mind blowing. A messy, gooey, splotch of garbage and scraps—X-rays, baby dolls, crummy photos, bad cartoons, cross-developed photos, mistakes, lens flares, junk, dirt, broken glass, teeth—collaged together on the cover spread of *Uncle Meat*. The visuals were a perfect echo of the music inside. I sat long hours next to my Magnavox record player listening carefully to those records and staring endlessly at the covers, trying to understand their meaning. I began to associate the images with not only the music but also with the discovery of a world previously unknown to me, where everything was different—where everything was totally accepted, no matter how demented. It was a pivotal point in my life.

WAS IT THROUGH THESE EARLY EXPERIENCES THAT YOU GRAVITATED TOWARD DESIGN AS A WAY TO MAKE A LIVING?

Schenkel pointed me in the direction of graphic design. It eventually became my life. Not just graphic design, but design that pushed boundaries and pushed hard. It pushed so hard that things began to break, but that would be okay. To this day, I still look at those covers and can't really figure out how Schenkel managed to achieve some of the graphic effects that he did—or how such effects so affected me. His imagination and ingenuity amaze me to this day. That is what I call good design.

YOUR WORK HAS BEEN DESCRIBED BY OTHERS AS SUBVERSIVE. YOU ARE A GREAT STUDENT OF SUBCULTURES AND GENRES EXISTING OUTSIDE THE MAINSTREAM. DO YOU RECOMMEND THIS ROAD TO YOUNG DESIGNERS TODAY?

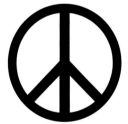

I find good ideas in subcultures. They fascinate me because they have invented their own language. Graphic design is a visual language. The visual language of subcultures can be vast but isolated, carrying meanings that one is not typically privy to.

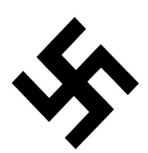

I encourage the research and exploration of subcultures and their visual languages. The fate of all subcultures is oblivion, but there are times when a particular subculture becomes so powerful and important that its visual language is absorbed by mainstream culture. Some of the old meaning remains, but the absorbtion alters the meaning, usually inaccurately. The peace symbol, swastika, psychedelia, surfer, punk, and drag are good examples of this.

RIGHT: THE PEACE SYMBOL IS UNIVERSALLY KNOWN. THE SWASTIKA'S MEANING HAS CHANGED VASTLY OVER TIME.

Are designers too often pigeonholed into creative disciplines and other such definitions?

Disciplines are artificial barriers drawn by commerce and the associated academia. The more the pie of creativity is divided, the more others can charge for every tiny slice of the process. Design is all about the creative process by its very definition. By its inherent nature it is cross-disciplined.

Tell us what inspires and motivates you.

Life. I'm not talking about beautiful sunsets, love, and good food. I'm talking television and cheesy magazines; cold, sterile shopping centers; and garbage. I am a contrarian. I find inspiration in the discards of culture. That is where most of us dwell.

How do you know when design is good?

When it achieves the level of art. But that requires patience, time. For example, I can't really evaluate my work at first. It's a client-driven process and, therefore, collaborative. A good design—whether it's a logo, poster, brochure, or whatever—exists within a commercial framework at its completion. It is not art yet. It only becomes art after its commercial life has ended (the concert happens, the sale is over, the product forgotten). Then it truly becomes mine. But even then, it isn't art. It is an artifact, a cultural remnant. The term *art* doesn't enter the picture until someone later redefines the design as art and it gets placed in an environment such as a museum, gallery, or private collection.

Is there such a thing as objectively ugly or distasteful design?

There is a place for pretty design, but over time it fades in importance. A lot of that type of design isn't even design; it's decoration. "Pretty" is a tool a designer uses—and not an important one. I use "ugly" a lot. I'm a master of ugly. I think my work is pleasing but many find it's unpleasant, shocking, or disturbing. But some still find Salinger's *Catcher*

in the Rye ugly and unpleasant. It is a matter of the language—style, accent, dialect—you choose. What is important is not the language used but that you reach your audience in a language they understand.

ANY FURTHER THOUGHTS ON THE DEFINITION OF GOOD DESIGN?
Durability. I want my work to survive. I like ideas that become part of the larger dialogue of, and definition of, design. I hope that some of my work is still being examined decades after my passing.

"I DON'T DO ART, I DO ARTIFACTS. WHEN I GET MY SAMPLES OF THE PIECE, I TOSS THEM INTO A DRAWER FOR SIX MONTHS OR LONGER. ONLY WHEN THE ELEMENT OF TIME HAS BEEN ADDED TO THE PIECE CAN I BEGIN TO ACTUALLY EXAMINE AND EVALUATE THE PROCESS FOR THE THINGS I VALUE."

ART CHANTRY'S WORK IS OFTEN STRIKING AND ICONIC, LEAVING A LASTING IMPRESSION AND PERHAPS CREATING A PLACE IN THE CULTURAL VERNACULAR.

Stanley Hainsworth
Owner, Tether
Seattle, Washington, USA

Stanley Hainsworth made his mark on the American design landscape as a creative director for Nike, LEGO, and Starbucks. Today, he owns Tether in Seattle. A trained actor (and self-taught designer), Hainsworth is also a gifted and natural storyteller.

WOULD YOU SHARE WITH US THE NAMES OF SEVERAL DESIGNERS WHOSE WORK YOU GREATLY ADMIRE AND TELL US WHY?
Philippe Starck. Every designer should emulate him. He's designed everything you can think of: motorcycles, restaurants, furniture, products, graphics, videos. He knocks down walls. He seems to understand everything.

Another example of this kind of multitalented designer is Michael Vanderbyl. The purist who defines him or herself as only a print designer or only an industrial designer or only an interior designer is really missing out on a lot of fun. I admire designers who are not easy to categorize. A lot of young designers these days are like that—they are not afraid to experiment with new media or work across other disciplines.

THE MEN YOU MENTION ARE MASTERS OF BOTH FORM AND FUNCTION. ON A MORE MORTAL LEVEL, WHAT SHOULD ALL DESIGN ACCOMPLISH?
Let me rephrase the question: "What should a good designer be?" They should be skilled storytellers. Acting helps. I recommend designers take some acting lessons. It helped me. There's little difference between auditioning and pitching ideas and concepts. Design tells stories.

MICHAEL VANDERBYL'S FURNITURE

Designers try to make emotional connections between products and audiences. Good design tells a narrative, with a beginning, middle, and end. Even a simple mood board should reveal a narrative, inviting the eye to follow seemingly random, collaged elements until the complete picture is revealed.

WOULD YOU GIVE AN EXAMPLE OF SUCH A NARRATIVE EXPERIENCE IN YOUR OWN WORK LIFE? Good design also evolves—just like a narrative. At Starbucks four years ago, we were into this handcrafted, illustrative type of design branding. It was a dense swirl—images and words. No one could really figure out the story

THE STARBUCKS STORY WAS GETTING MUDDIED BY TOO MUCH RANDOM DESIGN. THEN THE DESIGNERS REFOCUSED ON THE CENTRAL STARBUCKS NARRATIVE: THE STORY OF COFFEE, IN ALL ITS RICHNESS AND TEXTURE.

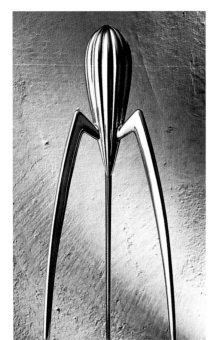

because there was just too much. So we redirected the focus to storytelling—the story of coffee, how it is picked, planted, roasted, and served.

YOU HAVE EXPRESSED YOUR DEEP APPRECIATION FOR DESIGNERS WHO ARE NOT TIED TO ANY SINGLE DISCIPLINE. WHY DO YOU PLACE SO MUCH VALUE IN CROSS-DISCIPLINARY DESIGN?
People want to put you in a box. Don't let them. Rather than telling them what you are, ask them what they need. Young designers today have abilities and interests across many areas. They're problem solvers, not graphic designers. They may have come out of a graphic design program, but a lot of them run their own small shop where they touch product design, website design, and print design. So whenever you think you lack a certain skill set or technical background in another discipline, don't let it stop you. Either learn it yourself or find a talented person who can collaborate with you to make it happen. You will still own the vision and the concept. It will still be your design. Do you think Philippe Starck hangs drywall or welds?

"I RECOMMEND DESIGNERS TAKE SOME ACTING LESSONS. IT HELPED ME. THERE'S LITTLE DIFFERENCE BETWEEN AUDITIONING AND PITCHING IDEAS AND CONCEPTS."

WHAT VALUE DO YOU PLACE IN AESTHETICS OR PLEASING DESIGN?
Art is pretty…Design is problem solving. If you want something that is just pretty or pleasing, that is not solving a problem. Art doesn't promote the new yogurt. Design does.

"GOOD DESIGN IS NOT ABOUT DECORATION. IT IS NOT ABOUT LOOKING COOL. EVERY GRAPHIC ELEMENT SHOULD SUPPORT A CENTRAL CONCEPT OF YOUR BRAND. EVERY GRAPHIC ELEMENT SHOULD BE A PART OF A BROADER NARRATIVE, A STORY THAT REVEALS A CENTRAL MESSAGE OF YOUR BRAND."

WHAT MOTIVATES YOU TO KEEP PUSHING FOR THE BEST SOLUTION?

When the client pushes back. When things go really well at the presentation, upset it. Say, "Wow, glad you liked everything. But isn't there something you'd like to discuss?" The only way your design is going to improve is to engage the client, push back, and constantly question the validity of the initial brief and your own responses to it. It not only makes you a better designer, it makes them better clients.

SO GOOD DESIGN IS ABOUT NEVER BEING SATISFIED?

Good designers embrace change. They crave constant evolution and improvement. Every designer should commit to a three-year cycle to rededicate themselves to their profession. Every three years, if you decide that the path you are on is a good one, great. Or, if you decide you want to evolve in a new direction, get off your present path. Every three years working for Nike, LEGO, or Starbucks I asked myself this. But I liked the path I was on because it continued to provide valuable lessons and experiences. But I realized after twenty years working for these big brands that it was time for me to start my next chapter.

WHAT DOES GOOD DESIGN DO?

It creates an emotional link between the consumer and a product or experience.

Good design stays on message. Don't start slapping logos on things that really have nothing to do with the core br and message.

Good design does not fade when the going gets tough, when the economy goes bad, when hiring and spending freeze. If anything, tough times reveal bad designs because people start assessing the core message and discover where and when the core brand focus was lost.

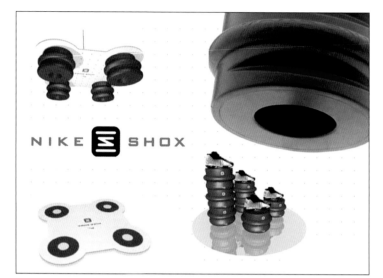

THE EVOLUTION OF STANLEY HAINSWORTH: LEGO, NIKE, STARBUCKS, AND NOW, TETHER

INTERVIEW: Henrik Persson

Art Director, Become

Stockholm, Sweden

Henrik Persson is the visionary behind Stockholm-based Become. A relative youth in the profession, he has generated startling design solutions, authored books and articles, and evolved his work by branching from two dimensions into three—from print to motion. Formally trained as a graphic artist and a journalist, Persson is thoughtful and surprising, and one of the most influential new voices in the design world today.

WHO ARE SOME OF THE GREAT DESIGNERS WHO INSPIRE AND INFORM YOUR WORK?

I draw most of my inspiration and satisfaction from architecture. The physical world that surrounds us also impacts us. It shapes our visual vocabulary, the way we express ourselves. Two architects/designers whom I find truly astonishing are Jacque Fresco and Jean Nouvel.

Jacque Fresco is an industrial and architectural designer and social engineer now living in Florida. He is ninety-two years old. Fresco's solutions are amazing to me. They are clever and beautiful. They are based upon the central concept that buildings should gain the maximum benefit for the greatest number of people. It is this inclusive vision that I admire. It informs my own work. (See the film, Future by Design.)

Jean Nouvel is the legendary futurist architect from Paris (www.jeannouvel.com). He triggers my emotions. His creations push the boundaries of shape and construction, grinding to dust known rules by taking complex shapes and stripping them down to their essence and simplicity. His use of natural light plays a tremendous role inside his work (see the Institute Du Monde Arabe in Paris, www.imarabe.org). He is currently building the Louvre Abu Dhabi.

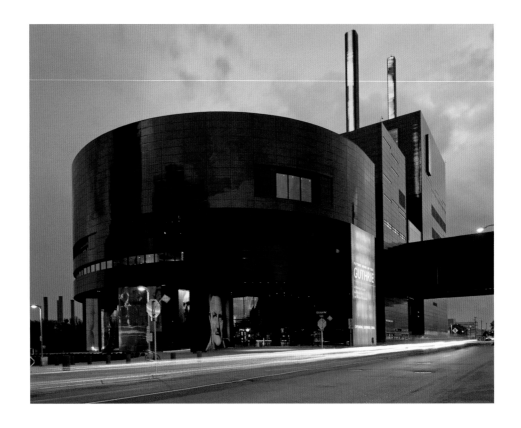

"JEAN NOUVEL USES THE PHYSICAL WORLD OUTSIDE TO PLAY A CENTRAL PART OF THE DESIGN WITHIN. LIGHT DEFINES THE BUILDING AND ITS MISSION."

JEAN NOUVEL'S GUTHRIE THEATER, MINNEAPOLIS (ABOVE) AND HIS ARAB WORLD INSTITUTE IN PARIS (RIGHT)

CAN YOU NAME A FEW DESIGN ELEMENTS CLOSER TO YOU, IN STOCK-
HOLM, THAT YOU BELIEVE ARE EXAMPLES OF SUCCESSFUL DESIGN?
Two designs in Stockholm that I admire are old sign forms on buildings. Both sit high on
their buildings and are most visible at night.

The Tulo sign is on a wall near my home. It was erected in 1955 to advertise a popular
brand of throat lozenge. It features a sequential light play, suggesting the lozenges are fall-
ing down the façade of the building. Its text reads, "Always take Tulo."

After it fell into disrepair in the early '90s, the company's refusal to repair it generated a
massive public outcry that included a boycott of the company's products. They fixed it. I love
it because it is so playful and old school. When an advertisement or signage design remains
popular enough to inspire public affection decades later, you have a successful design.

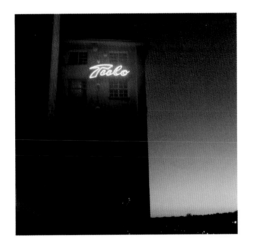
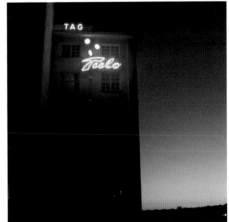
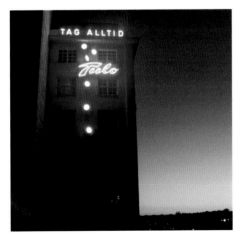
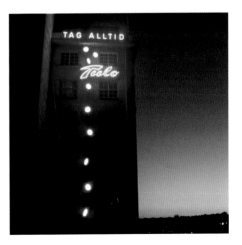

THE TULO SIGN IN STOCKHOLM, SWEDEN

> "FOR ME, THERE IS NO THING SUCH AS 'CORRECT.' GOOD DESIGN IS ABOUT GETTING TO THE TRUTH."

YOUR WORK IS CROSS-DISCIPLINARY. WHAT MOTIVATES YOU TO GO BEYOND THE LIMITS OF YOUR MOST COMFORTABLE DESIGN ZONES?

I believe boundaries between disciplines should be rubbed out. Architects and graphic designers should simply be called designers or innovators.

HOW DO YOU EVALUATE WHETHER OR NOT A DESIGN IS SUCCESSFUL?

I measure against the creative brief—or at least what I think the brief should have been. If the design does not meet the client's need, answer the client's question, or solve the client's problem, it has not served its purpose.

HOW DO YOU KNOW WHETHER OR NOT YOU HAVE A PROCESS THAT WILL LEAD TO A SUCCESSFUL DESIGN SOLUTION?

Good design is about getting to the truth. It requires you to dig deep in order to understand a client's business. Sometimes, the original brief leads you off in the wrong direction. It's up to you to find the appropriate path. The development process can do this by revealing truth and meaning hidden in the cracks. It can lead to things much more significant than what the original brief would suggest, leading to a final solution that is much stronger than it otherwise would have been.

DO YOU VALUE AESTHETICS IN GOOD DESIGN?

Pretty and stylish is not inherently wrong. It might be the appropriate tool of expression required to communicate a feeling or mood, but too often we see design that expresses merely fashion and trends. Such work makes no impression whatsoever. Pretty for pretty's sake is purposeless.

OUTSIDE OF ARCHITECTURE AND SOME OF THE HEROES YOU MENTIONED, WHERE DO YOU FIND THE MOST INSPIRATION?

In the world around me. In the concrete, such as man-made and natural things. In the abstract, such as shapes, angles, color combinations, atmospheres, feelings, and moods. The ultimate goal of good design should be your own personal satisfaction and that of your client.

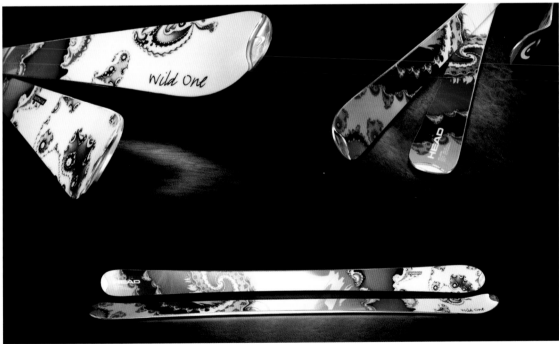

HENRIK PERSSON'S WORK HAS BLURRED BOUNDARIES, SPANNING TEQUILA FOR PATRONA TO SKI EQUIPMENT FOR HEAD.

VEGETABLE PEELER

MATTEO BOLOGNA, MUCCA DESIGN

I have nothing but good things to say about this fine personal defense item. I always carried one with me while in residence at San Quentin. The stabbing precision is comparable to the Bonny Scottish Dirk Dagger (my second choice for personal defense).

The shorter length allows for easy concealment, and thanks to the versatility of its design, it can also be used for trimming nostril hair. They tell me someone once used it to peel vegetables.

ELLIOT STRUNK, FIFTH LETTER

I've never really thought deeply about a carrot peeler before and, to be honest, I've probably used one on more potatoes than I have carrots. This is a wonderful example of form following function. If you've never seen one in use, you'd likely have no idea what this is or how it works. Hand one to a child and see if they can guess. But like the "church key" used to pry open paint cans with one end and beer bottles with the other, it's a simple device that has incredible shelf life. The design has remained virtually unchanged for decades. It's ubiquitous. I'll bet all our readers have one in a kitchen drawer right now.

So why are you still reading? Put the book down, find your carrot peeler, and begin preparing for a tasty stew.

ENSI MOFASSER

The cruel design of this tool is too often overlooked. The steel handle is too short and pokes a hole in your hand and the thin steel edges dig into your flesh. It makes an annoying rattling sound, and it can easily flip over in your hand and mistake your

fingers for the potato. Interestingly enough, this tool is found in almost every kitchen drawer, and didn't seem to call for improvement for over a century.

It wasn't until the beginning of the 1990s that new and improved peelers entered the market. The new peelers, developed by companies like OXO Good Grips and Michael Graves, have a new design that is more ergonomically suited for your hand. It has a soft cushioned handle that is nonslip even when your hands are wet. And the sharp blade has a built-in potato-eyer!

ROBYNNE RAYE, MODERN DOG
It's old school and built to last.

INTERVIEW: Joel Nakamura

Illustrator

Santa Fe, New Mexico, USA

Santa Fe illustrator and fine artist **Joel Nakamura** is immersed in graphic design every day. Designers love Nakamura's remarkable and complex illustrations imbued with symbology, myth, and history. Nakamura, in turn, loves design and has a great understanding of what kind of design works and what does not. "Most of my friends are designers...but don't hold it against me," deadpans Nakamura.

WHEN DO YOU KNOW A DESIGN IS GOOD?

When it arrests your attention. When it's cool. When the work embraces everything about effective design. When David Carson entered the scene, his work was difficult to read. But you had to pay attention to it, you had to put up with it, because it was different from anything anyone had seen before.

WHAT MAKES A DESIGN BAD?

When it doesn't do anything. When it fails to draw an emotional response. When it does not challenge the viewer to find out what the hell it is trying to say. Carson is what I call "double black diamond reading." If there isn't a risk, if there isn't a thrill, then there isn't a payoff or a challenge to the subconscious. I also like Carson because he always hides genitals in his designs. Just kidding. Maybe.

DOES GOOD DESIGN ALWAYS HAVE TO BE HIP, COOL, AND UNREADABLE TO MAKE YOU HAPPY?

No. I was exaggerating to try to encourage others to take risks. Sometimes, good design is simply intelligent. Sometimes, good design is merely functional. For example, think about

"EVERYTHING IS DESIGN."

DAVID CARSON'S WORK
INSPIRED A GENERATION
OF EXPERIMENTATION
AND THE WIDESPREAD NEED
FOR READING GLASSES.

the work of Kit Hinrichs at Pentagram San Francisco. Cool isn't the first thing that comes to mind when you think of Kit. But his work is clean and intelligent. It always communicates a specific message for a specific audience very well. And it is cool when you are the kind of designer who can always satisfy the client.

Good design addresses the things it needs to address. It speaks in a language its audience can understand. And you certainly remember it. Examples lie everywhere.

For instance, this salami package really stood out to me in the sausage case at the

KIT HINRICHS'S REDESIGN FOR MUZAK ISN'T
EARTH SHATTERING, BUT IT IS APPROPRIATE
TO THE CLIENT AND ITS MARKET.

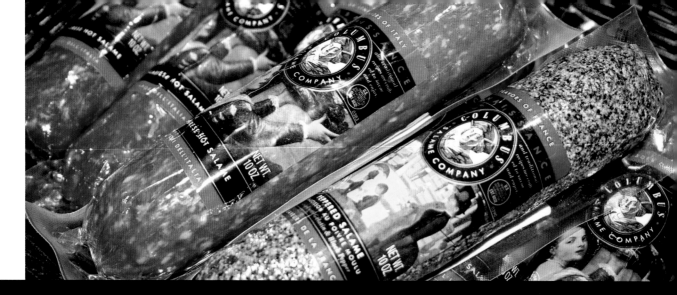

grocery store among all the other salami options confronting me. I believed it. Heck, I bought it. Later, I dug around and discovered that the package design was done by Hinrichs's San Francisco office. Clean, simple, and well done. Clean functions well in society. It registers with people and makes an impact even if we don't necessarily know why.

What value do you place on aesthetics or beauty in good design?
Form apart from function has its place. I'm a painter. I like beauty. Designers are visual people. They like beauty. But how we define that is different for everyone. For some, it is clarity. For others randomness and chaos. One man's beauty is another man's ugly.

How do you evaluate good design? I think it is clear cut. An illustrator cannot be self-indulgent. A fine artist can. As an illustrator, the client has to be served. That is exactly what good design has to do; it has to be distilled through the filter of the client's needs.

Does good design carry responsibility?
Good design functions in the real world. It has a responsibility. It has goals. If the piece does or does not help meet the goal, say sell the salami or drive tourists toward the amusement park, then there is a consequence. If the sign doesn't communicate a vital piece of information—slippery when wet, for instance—then there is a consequence. Nothing I do can affect life and death. A bad painting might annoy you, but bad design can kill you.

> "NOTHING I DO CAN AFFECT LIFE AND DEATH. A BAD PAINTING MIGHT ANNOY YOU, BUT BAD DESIGN CAN KILL YOU."

YOU HAVE A DISTINCT STYLE AND VOICE, A NECESSITY FOR AN ILLUS-TRATOR. WHAT ARE THE PROS AND CONS FOR DESIGNERS WHO HAVE A CLEAR VOICE?

There are basically two types of designers. One who is versatile—who can create a variety of solutions and more easily expand their clientele base. But these designers run the risk of not distinguishing themselves from the crowd.

The second type of designer has a clearly defined style that is distinguishable from all others. They are sought for that style. Their trouble comes when their particular look, trend, or style becomes old or trite. These designers run the danger of going out of fashion and getting left behind.

JOEL NAKAMURA ADMIRES THE WORK OF GIANT ROBOT, RYAN MCGINNIS, AND GENEVIEVE GAUCKLER. THE REASON FOR ALL THREE IS THE SAME: "TOO MUCH COMMUNICATIVE EFFORT DOESN'T WORK AND GETS LOST. I WANT TO BE CHALLENGED. I RESPOND STRONGLY TO THIS KIND OF WORK."

WERE YOU EVER AT RISK OF GOING OUT OF STYLE?

In the '80s, I had a trendy style. It had to go. I decided I wanted an approach that was timeless. One that didn't rely on visual gimmicks. I wanted my voice to transcend any that could be pegged to a particular time or era. I hope I have achieved that.

JOEL NAKAMURA LIVES OUT HIS CHILDHOOD
AND BEST WISHES IN HIS TIMELESS STYLE.

Nick Jones
Creative Director, Browns Design
London, England

Nick Jones is creative director of Browns Design in London. The work there is distinguished by its simplicity and power. It is broad ranging, from financial services to fashion. What unites this company's design is the primacy of the concept brought to life with intelligence and restraint. Jones' insights make it clear that he is at once intelligent, adroit, and always looking toward a new horizon. Good skills to have in life. Good skills to practice in design.

NICK, WOULD YOU TELL US WHAT KIND OF DESIGN MOST APPEALS TO YOU?
The work of Graphic Thought Facility (GTF) here in London is one group I really admire (www.graphicthoughtfacility.com). They are skillful craftsmen who know how to use their reference points—two elements I believe are crucial to good design. They are also versatile, working for multinational corporations, museums, small galleries, and small businesses. They always produce something original even though they don't have a definable house style. Their work jumps all over the place because they study and respond to the criteria of every job.

YOU ARE A STUDENT OF DESIGN HISTORY. WOULD YOU NAME SOMETHING FROM THE NEAR PAST THAT YOU WOULD CLASSIFY AS ENDURING—THEREFORE, GOOD—DESIGN?
When I first saw the FedEx logo at the Cooper-Hewitt Museum in New York City, I was struck by it. Every time I see one of their trucks, I say to myself, "That's a great mark." That's because it functions as a strong mark for a global business irrespective of whether or not you see the arrow. But that arrow sends the subliminal message "expedite." I've been in boardrooms and pointed out the arrow to chief executives who had never noticed it before. Upon recognition, the smiles that spread across their faces are a joy to behold.

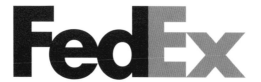

WHEN SPEAKING ABOUT GOOD DESIGN, IS IT EVEN RELEVANT TO IDENTIFY
THE DISCIPLINE?

We work in all sorts of disciplines. A good designer thinks bigger than the particular
application they have in front of them. This extends to the disciplines in which you can
participate. But the real secret is to find people with the technical knowledge and ability
you lack who can help you get to what you are trying to achieve.

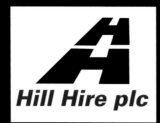

"HILL HIRE IS ONE OF ENGLAND'S LARGEST TRUCK
AND TRAILER RENTAL SPECIALISTS. THE TYPE IS
NOT GOOD, BUT I LOVE THE MARK. I'M NOT SURE
WHO DID IT, BUT WHEN I SEE IT ON THE MOTORWAY,
IT ALWAYS CATCHES MY EYE. IF PENTAGRAM HAD
DESIGNED IT, EVERYONE WOULD BE PURRING."

DOES "PRETTY" OR "PLEASING" PLAY A VALUABLE ROLE IN GOOD DESIGN?

It depends on the client, the end use, and the audience. Fashion needs impact, beauty, and
creativity to seduce consumers, but its seasonal nature means it can quickly be forgotten.
Things have a shelf life. Even a global identity may need a distinctive repeat pattern based
upon another design element from the identity to help it cross over to other integral com-
munications. Are such things purely aesthetic and seductive? Not necessarily; over time
they can become an integral part of the company's brand.

IS IT DIFFICULT TO EVALUATE GOOD DESIGN?

Evaluation is hard. I always say that is for others to judge but, that said, you know when
something is working or not. First, I like to be challenged. Jonathan Ellery, founder of
Browns, is a good editor of what is good and he knows how to challenge the guys in the
studio. The phrase we use a lot around here is, "Make yourself feel uncomfortable. That
way, you don't stand still." It works.

"My criterion for good design is based on two questions: Do I wish I'd done it? Would I steal it?"

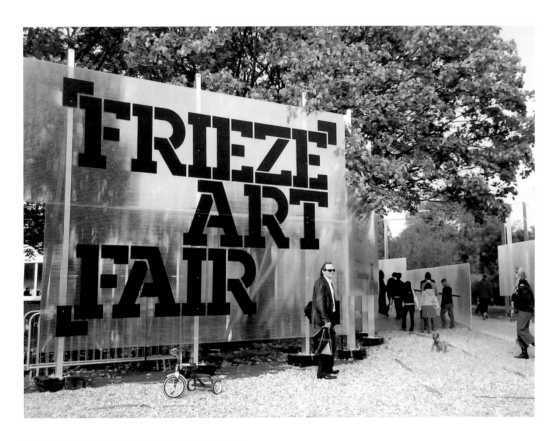

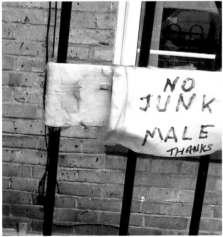

ABOVE: MARKETING CAMPAIGN BY GTF FOR THE FRIEZE ART FAIR

LEFT: "THIS IS A GREAT EXAMPLE OF A HAND-MADE SIGN WITH BAD GRAMMAR. IT ALWAYS MAKES ME SMILE."

"THESE ARE VARIOUS SHOTS OF TYPE ON BUILDINGS.
I HAVE ALWAYS LIKED THE FACT THAT THEY ARE
NOT DESIGNED IN THE MODERN SENSE, BUT HAVE
A SENSE OF CRAFT."

How does process play a role in the creation of good work?
It is vital. Especially in editing down ideas. Understanding your influences and reference points is even more critical. When a designer can mix old and new, understand his or her reference points, know the origin of ideas, then he or she can create more stimulating work, tell better stories, and help persuade clients. It becomes even more important how you then present your influences and ideas in today's world with all its touch points and myriad mediums. But it is an exercise to be enjoyed. An effective design process is always very much about the edit—this typeface or that, this material or that one, this editorial or another, and so on. But the process is also about enjoying the friction that arises as you make decisions. Contemporary, for example, isn't always Helvetica tightly spaced in Flouro foils—it can be about woodcut in modernist surroundings.

"Picasso and Cézanne are known for abstract and cubist works, but both were superb technical draftsmen who could draw beautifully and accurately. Without this training and understanding, they would not have been able to create the works for which they are best known."

In these works for Hazlitz and Invesco, Nick Jones shows his flair for both type as a design form and playing to the abstract even in unexpected places.

Sandra Equihua and her husband and collaborator, **Jorge Gutierrez,** are cocreators of the the Emmy award–winning cartoon *El Tigre* on Nickelodeon. She grew up in Tijuana and, like many from that city, came to San Diego for opportunity, thus helping to make it one of the most vibrant visual arts communities in the West. She began her career in design, but she soon developed skills in illustration, voice acting, and animation. She is heavily influenced by the midcentury giants of illustration as well as Mexican folk craft and anime from Japan. Her paintings have been exhibited in Mexico and the United States, and her clients include Sony, McGraw-Hill, and Disney.

SANDRA, WHEN YOU SEE GOOD DESIGN, WHAT IS IT THAT APPEALS TO YOUR SENSES, YOUR INTELLECT?
Simplicity. Clarity. Spareness. When more detail is appropriate, a good designer ensures that it is both pleasing to the eye and well controlled and organized. The chalkboard metaphor for this: Plain and empty aesthetically pleases me. When it is covered with too much content, it becomes visual white noise, hard on the eye. But when you add color and organization, it welcomes you back.

TELL US ABOUT SOME DESIGNERS YOU MOST ADMIRE AND WHY.
Mary Blair and Miguel Covarrubias are two. They are great. They use shape and color to create awe-inspiring designs. Jim Flora is another who comes to mind. He is best-known for his jazz and classical album covers that fuse different design styles.

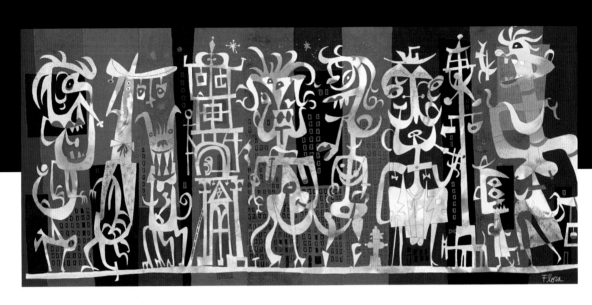

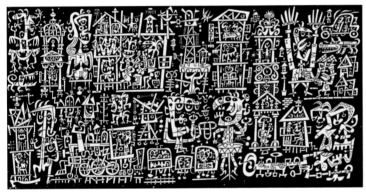

ABOVE: JIM FLORA'S WORK HALF A CENTURY AGO TEEMS WITH POWER IN ITS COLOR AND LINE WORK.

RIGHT: "THIS IS BEAUTIFUL HANDMADE TYPE I FOUND IN THE HOUSE OF BLUES."

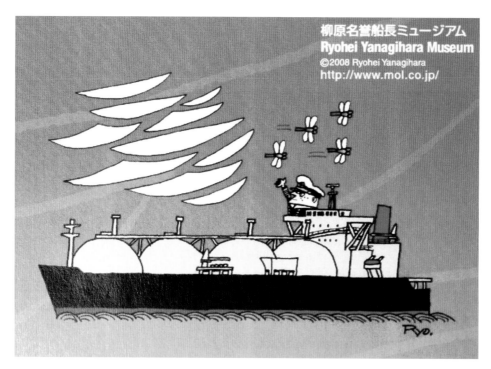

RYOHEI YANAGIHARA'S WORK FOR MITSUI OSK LINES EARNED HIM AN HONORARY CAPTAINSHIP AND HIS OWN MUSEUM, WHICH ALLOWS POSTCARD DOWNLOADS SUCH AS THIS ONE.

YOUR WORK CROSSES DISCIPLINES QUITE A LOT. WHO ELSE DO YOU ADMIRE WHO DOES THE SAME?

Ryohei Yanagihara. He uses simple shapes to create whimsy. And he is cross-disciplinary, employing design and illustration to create something more powerful than either alone. Color, concept, and shape are the keys to the gateway of cross-disciplinary design. Master them and you can explore a myriad of other work such as illustration, sculpture, character design, and motion graphics.

HOW DO YOU VALUE AESTHETICS OR BEAUTY IN GOOD DESIGN?

Even the ugliest design can have a useful purpose so long as it sends a message that elicits a reaction. Good design is all about function. So yes, there is a place for pretty design or just plain pleasing, if the function is merely to look pretty or please. But good design takes it further. Good design pushes. Good design has a mission—to communicate.

SANDRA EQUIHUA MELDS THE INFLUENCES OF
MIDCENTURY GIANTS AND HER MEXICAN HERI-
TAGE IN HER OWN WORK, BE IT ART OR MORE
COMMERCIAL ENDEAVORS.

RADIO FLYER

JOEL NAKAMURA

I like it because it is a time machine. I remember them looking just like this when I was a kid.

The manufacturer left the design alone. Good for them and good for children. No reason to change it. It's classic. Just add a GPS navigation system, and the modern kid is ready to roll.

STANLEY HAINSWORTH, TETHER

The Radio Flyer wagon is everything needed and nothing more. It's perfect in its practicality, from the slight curve in the handle to allow you to walk upright when pulling it behind you, to the curved lip on the top of the bed to allow smooth loading and unloading of children, dogs, and cargo. It's got sturdy axles, wheels, and no-flat tires to allow for a lifetime of smooth rides. Perfect.

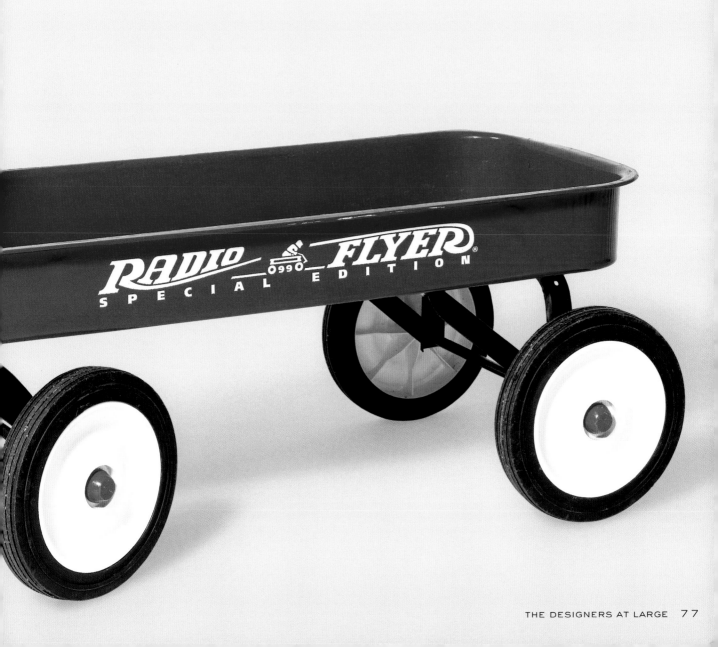

THE ETERNAL FLAME

Peer respect and design immortality are, of course, something we all desire. Even the most luminary names among us fear the opposite: a forgettable career. Peer approval is benediction. It tells us something about ourselves and lends us definition. If lucky enough to earn it, we might get free of some our most paralyzing self-doubts—that we are merely faking it, that we are more lucky than good.

Earning respect is difficult. It floats back just as it seems within reach—the mirage of respect. The only thing we can do is keep learning from our mistakes and honing our skills. We must continuously seek work better than our own to emulate. We cannot grow complacent.

Approval is nice. But it's not the ultimate goal. As you have read here, one person's definition of good is another person's definition of something wholly different. We cannot bend like a reed every time an opinion blows in our direction. Good work requires integrity and courage.

So will you become a design immortal? I'm not sure it matters. The only thing within your control is what you plan to do with each God-given day. Get up and get after it.

Heidegger wrote that people "pursue that which retreats from us." Tao instructs us be free from desire. Goethe reminds us, "Trust yourself and you will know how to live."

>> INTERVIEW: Steve Watson
Partner, Turnstyle Studio
Seattle, Washington, USA

Turnstyle Studio in Seattle produces world-class work that makes a big impact. Some people find it smart. Others think it's smart-ass. Whatever you think, Turnstyle is a vital participant in a new generation of design in a city known for great design. What distinguishes good design from great design? When you find your work imitated by your admirers. Turnstyle's work is. Yes, imitation is the sincerest form of flattery. **Steve Watson** is a huge part of Turnstyle's success.

WHERE DO YOU LOOK FOR INSPIRATION AND GREAT DESIGN?

I am often blown away by new media work that has the added dimension of motion and sound. I would love to learn how to do more of it myself, but I already have such a long to-do list. Then again, I don't know how to do my own taxes at this point either, but I think I'd rather learn new media than learn how to be an accountant.

WHAT DESIGNER OR DESIGN FIRM FLOATS YOUR BOAT?

I am impressed by those who can deal with über-complexity, such as the process-based philosophy of the design firm Lust. They once indexed a book by counting up how many times every letter of the alphabet appeared in the book—the index for the letter A alone took up like seven pages—mind boggling. Why do I regard such things as good design? Because I wish I'd done it, even though I know I never would have come up with the idea. My brain doesn't work that way.

When I heard creatives from Lust speak about their work and process, I felt like I had been transported to another dimension. Good design does this. It can turn you inside out. It steps on your head.

You use humor a lot. You like to laugh and make others laugh. What role can a sense of humor play in communication?

A lot, if you have a good one. A designer whose sense of humor appeals to me is David Shrigley. His is completely bent. He offers a perspective that is both hilarious and random. His style is often simple and undesigned, a perfect example of form taking a backseat to function. It makes you look. He makes you get it. Words and design are inseparable and

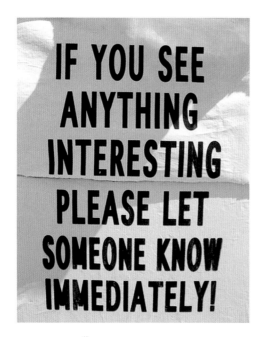

LUST'S "GENERATION RANDOM"

ABOVE LEFT: "I ENJOY DESIGN THAT COMBINES HUMOR WITH SMART, SIMPLE GRAPHICS. LIKE THIS SIGN, FOR INSTANCE."

ABOVE RIGHT: SCREEN GRABS FROM THE FILM *STRANGER THAN FICTION* WITH MOTION GRAPHICS BY MK12

CHARLEY HARPER'S WILDLIFE ILLUSTRATIONS

"WHEN DESIGN DISTILLS SOMETHING TO ITS ABSOLUTE ESSENCE, IT REVEALS ITS PURE TRUTH, LEAVING THE VIEWER THINKING, 'OF COURSE!' I LOVE THAT STUFF. I CALL IT ÜBER-SIMPLICITY."

feed on each other. A simple typographic poster with a funny or arresting headline will bowl me over much more than some complex, photographically rich and layered design.

FINDING WORDS TO DESCRIBE SIMPLICITY'S APPEAL IS NOT SO EASY.
CAN YOU EXPLAIN IT?

Good design can boil a thing down to its essence while still maintaining its interest. Take for example the animal and nature art of Charley Harper. He calls it "minimal realism." Instead of trying to put everything down, he tries to leave everything out. He distills reality in order to enhance the identity. Harper once said, "I never count the feathers in the wings. I just count the wings." When design achieves such a level of simplicity, it's brilliant. It's exciting. And it resonates with many of us.

How do you define or evaluate good design?

There are many styles and genres that are good. But it is the skilled application of fundamental design principles that distinguishes good design.

Why does so much design fail?

Because it is so overwrought. I take a "first, do no harm" approach in terms of the messages I'm sending or the products I'm promoting. Good design has a responsibility to avoid visual pollution, to minimize environmental impact, to eschew moral degradation. Good design can improve the human experience through visual clarity that fosters understanding, simplifies complexity, or simply delights the audience.

Do you respect any design that fails to exhibit such a world awareness and human sensitivity?

Look, to be a good graphic designer, you should be obsessed with being aware of what is going on around you. You have to like moving from subject to subject. You have to be good at taking in this information and visual stimuli and distilling it down into astute observations and comprehensible constructions. If all you care about is just graphic design, you live in a lifeless cul-de-sac and your audience is only yourself and people just like you.

"SUBJECTIVELY, SWISS STUFF GETS ME EVERY TIME, ESPECIALLY WHEN THE DESIGN IS A COMPLETELY NEW TAKE ON THAT AESTHETIC. CALL IT NEO-SWISS, OR NUEVO-NEO-SWISS, OR WHATEVER. I APPRECIATE DESIGN ROOTED IN A SWISS AESTHETIC THAT REINVENTS THE GENRE AS WELL."

NEO-SWISS EXAMPLE BY NONFORMAT

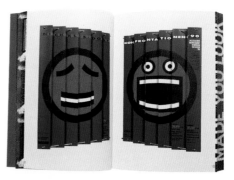

MADE YOU LOOK BY STEFAN SAGMEISTER

WHAT GIVES YOU THE GREATEST SATISFACTION?
Getting a reaction. Making people laugh, amusing and delighting them. If my work cannot do that, at the very least I want it to enlighten them.

I identify with the title of Stefan Sagmeister's book, *Made You Look*. That's what it's all about. I don't care about being a celebrity. I just crave reaction. The creative process lets me get it.

WATSON'S WATCHWORDS FOR DESIGN: "STEER CLEAR OF SPRAWLING ORNAMENTATION, SILHOUETTED BIRDS, DERIVATIVE INDIE ROCK POSTERS, FOCUS GROUPS, PSEUDOSCIENTIFIC SURVEYS, AND DESIGN STRATEGY HANDED DOWN BY MARKETING OR THE PRODUCT."

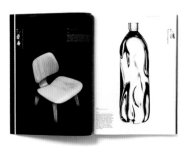

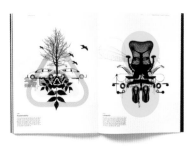

WATSON'S WORK AT TURNSTYLE POSSESSES SWISS RESTRAINT AND EXUBERANCE.

Mucca Design "founder and father figure" **Matteo Bologna** left Italy years ago, but he retains his native lust for life. Whether it's designing a complete branding system for such popular New York establishments as Balthazar and Butterfield Market, or branding the Rizzoli/BUR, Mucca's work is grounded in traditional craft and style and rooted in historic reference, but always pointing toward the future. A conversation with Bologna is its own adventure, as hi s wit, intellect, and sense of play make you feel more like you are playing a game of hide-and-go-seek rather than getting into his head. One thing is for certain: With Bologna, you end up where you started—utterly delighted.

PLEASE TELL US THE NAMES OF SOME DESIGNERS WHOSE WORK YOU HAVE LONG ADMIRED.
Charles Spencer Anderson.

He is very famous. He is an idol to me because I never studied graphic design and my sources of inspiration were coming from books. I used Type Directors Club books as schoolbooks. Anderson's designs always appealed to me because of the craftsmanship and the fact that his approach was totally new twenty years ago. Good design is very distinctive and very different. This makes it timeless. And often copied.

CAN YOU THINK OF SOMEONE ELSE?
Yes, Louise Fili. I hate her. I love her. I hate her. You know how it is. I am very envious of her. Sharon Werner, too. She hurts me she is so good. I hate her. My preference is toward

LEFT: SHARON WERNER'S PACKAGE DESIGN FOR MRS. MEYER'S CLEAN DAY

BELOW: LOUISE FILI'S PACKAGE DESIGN FOR BELLA CUCINA DOLCI BISCOTTI

people who use history in their design. Rodrigo Corral is another. He understands history, and he knows how to use it to make things fresh. Practically all U.S. book designers are fantastic. I hate them. Love them.

WHAT ELSE DO YOU HATE THAT IS GOOD?
Bauhaus. I hate it. Any approach like Bauhaus where everything should look the same I hate. In Milan, where I come from, all the design is product design, and much of it is very clean. This look is largely based on the work of designers from Milan, the design capital in the '60s. Yes, it is very influential, this modernist style. I see it everywhere in graphic design but only Massimo Vignelli could do it well. But I got bored with it, bored with Helvetica—always the same thing. The fact is, it's kind of emotionless because it's part of

RODRIGO CORRAL'S
BOOK COVER FOR *THE
BRIEF WONDROUS
LIFE OF OSCAR WAO*

this belief that all design must be universal. "Universal language to solve the world's problems," they tell us. Which is not true. Design is about artistic expression. It is not science even if there's some science or technical skill behind it.

Okay, so how do you define good design?

It depends on who is doing it. Who has the skills and tools to do it well? For example, I can say something and you are not convinced. But Robert DeNiro can tell you the same thing and you are convinced. He is trained to speak the sentence convincingly. I hate him for this. Really. But the main intent of good design is to get your client's message across with the target audience. That's successful design. It is not that complicated, really.

How do you evaluate the success of your own work?

I feel I'm successful when I don't have to explain myself to the client, when I don't have to give them feedback. They get it. I understood them. They understand me. We both can move on. Success also is when I see something I did a few years ago and still like it.

How do you evaluate the success of someone else's work?
In other people's design, it's good if I can copy something from it, if I can find in it something valuable to use in my own work. That's why I have a lot of magazine subscriptions. I am constantly looking for things I admire, things I can use.

But how do you decide what is good or bad design, as you thumb through magazines?
If it's shit, it's because you designed it. Shit is never the client's product. It's your fault. It's your fault because you didn't fight enough for the best result. Because you gave up. But you know, sometimes you have to give up. That way you can continue. Sometimes, the client doesn't even deserve it, all your effort and time. But first, love yourself, don't hate him. You know it's your own fault if you don't do a good job, so accept it and fight harder next time.

> "The main intent of good design is to get your client's message across with the target audience. That's successful design. It is not that complicated, really."

Are you motivated by money or the glamour of your work?
I am motivated by work I enjoy that also makes money. We work eight, ten hours a day and want to be paid for these ten hours of the day, but I also want to have fun. I don't see why you should do something that you are not happy doing. You should put the same energy into something you do for a well-paying client as you would for a nonprofit or pro bono client. You know, I can do work for myself and enjoy it, but I need to find the same kind of enjoyment in doing work for someone else. So, have fun with your own self-produced work but have fun with your client's work as well, because if you don't have fun, you won't give them a good result.

What is the one thing a designer should seek that will make her or him better?
Time. I would like to learn how to do motion graphics. I know a little Flash; that doesn't count. I was too busy to learn how to be good at it. That is the true problem success brings at some point in your career: You don't have time to learn new stuff. You cannot stop everything and immerse yourself for days. At least, while I am at the office I cannot do it. In the evening I am too tired. Once, I took a long vacation and all the time I had for myself I spent working on fonts. Type design requires long hours. I'm thinking of some of the

typefaces that I designed. I'm proud because I did them—not because they are good—but because the process of designing typefaces is so painful. Just being able to have one that I did, it's enough. I've designed a lot of typefaces. The question should be how many did I finish? Very few.

What other disciplines do you know?

We are painters, but we use type and images. So at the end, you know, we use typography, photography, illustration, and text. I am like a director. Fellini. The only thing that we don't do is motion. Fellini did motion. I hate him.

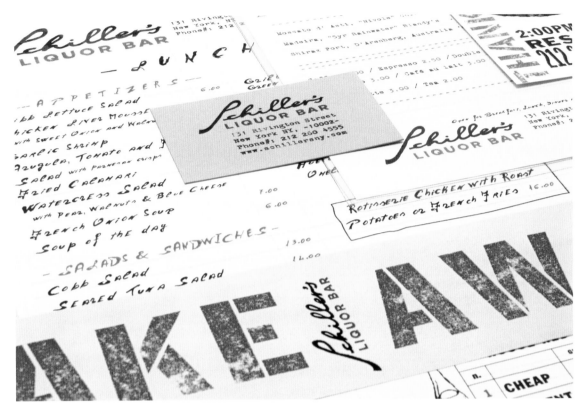

ABOVE AND OPPOSITE: BOLOGNA'S OWN WORK INSPIRES OTHERS TO A PALPABLE HATE AND JEALOUSY AS WELL.

As bass player for fluf, an iconic San Diego rock trio, **Josh Higgins** joined the creative culture in San Diego by headlining around town. Soon he traveled the country as the group toured with notable acts like Jawbreaker, Fugazi, Blink 182, and Sublime. By the mid 1990s, Higgins' music led him to study design and eventually to establish himself in the field not just locally, but internationally as a result of his design work for Fender Musical Instruments, The Tony Hawk Foundation, Museum of Contemporary Art San Diego, KROQ FM, and Perry Ellis International. Through his work with AIGA, he contributes to San Diego's growing design community and mentors art and design students. And somewhere in there he continues to play music and produce award-winning work for clients.

NAME SOME DESIGNERS AND THEIR WORK THAT YOU FIND INSPIRING—THAT HAVE INFORMED YOUR WORK.

So much we see out in the world works well enough, but little of it makes a lasting impact. There's the functional—and then there's the truly good. I believe it is easy to spot the difference. Paul Rand's work was simple, innovative, and rebellious. He employed a wide variety of design techniques including typography, collage, and photography. This combination of elements produced distinctive design across many media, such as poster design, editorial, and corporate identity. But simplicity was the common element across everything he created, no matter what the medium.

This magazine cover has always been striking. When you place it in the context of the 1940s, it is remarkable for its level of conceptual thinking. This was a much more conservative time

period. I am sure this cover design was extremely controversial. And when you think about the level of art direction that this example represents, it is simply incredible.

WHAT ABOUT A CONTEMPORARY FIGURE?

For many of the reasons I look to the work of Rand, I am inspired by Reid Miles—one of the most underrated designers ever—for his simplicity and exercise of restraint. His use of type was very progressive for its time. His album covers defined a whole genre of jazz with a look. His cover design for Blue Note Records blended modernism and photography. His most memorable covers incorporated dynamic typography with Francis Wolff's eloquent photography. His cover for a Freddie Hubbard album was the first of his covers I ever saw. Even after buying every book on his work that I could ever can get my hands on, it remains my favorite.

FOSSIL WATCH

CAN YOU THINK OF SOME-
THING ELSE THAT YOU REGARD
AS GOOD DESIGN—PERHAPS A
PRODUCT OR PACKAGING THAT
HAS INFLUENCED YOU?

Yes, I purchased a Fossil watch for its design. I find its combination of dark wood and chrome unique. But what sold me was the way the numbers on the face come from behind the crystal onto the outside of the watch. I am a sucker for whenever someone uses type in an unconventional way.

I also love Apple's iPhone packaging. Its subtle use of embossing and lack of overt branding is so eye catching. But this great package design does not stop on the outside: When you open the box, all the pieces fit together thoughtfully. It is a great packaging experience, not just a nice package.

Jason Munn's posters always have an element in them that makes you think, "That's a great idea!" They are conceptual and that is what I like about this one. The use of a shadow as different from the object casting it is not new, per se, but the way he uses it here is a fresh take on a well-worn concept. I love its simplicity, the use of type, and its thoughtful execution.

IPHONE PACKAGING

JASON MUNN'S POSTER FOR THE DECEMBERISTS

THE ENTRY TO THE STARLITE IN SAN DIEGO, CALIFORNIA

Helvetica Neue_Light

Helvetica Neue Light is simply beautiful.

I love the use of materials in the interior at the Starlite. Bells and Whistles, an interior design firm, used materials normally reserved for exteriors. You see a mixture of stacked stone, wood, cork, and mirrors. But what really strikes me is the use of stag horn planters on the stack-stone walls. The combination is fresh, unique, and memorable.

DOES GOOD DESIGN OFTEN DEPLOY DIFFERENT TECHNIQUES AND DISCIPLINES?

The creative principles found in design can be used to develop new solutions for many industries and businesses. The marriage of creative right-brain thinking and analytical

left-brain thinking is often a critical determinant of success because innovation and new insight often occur not at the center of one discipline, but in the spaces between the two. A lot of value is being created at the intersection of design and business; mixing disciplines such as environmental and interactive design has much to do with this new value.

How do you value aesthetics or beauty in good design?

There is no place for simply pretty design. Good design needs a strategic basis defined by conceptual thought no matter how small its challenge or purpose. Good design must speak to the "why" of the task. I aspire to simplicity and strategic thinking with every project I touch.

What gets your creative juices flowing?

When design helps those in need. I am motivated to find the best solution to solve a problem, especially a social problem. I try to do one or more pro bono projects every year that do precisely that. If there was a way to do this kind of work full time and still support myself, I would.

HIGGINS' OWN WORK EXEMPLIFIES HIS CRITERIA OF GOOD DESIGN: SIMPLE, GOOD TYPE, STRONG CONCEPT. **LEFT:** FLUF/ARMCHAIR MARTIAN CONCERT POSTER; **RIGHT:** 504 WAS CREATED FOR DISASTER RELIEF IN THE WAKE OF HURRICANE KATRINA.

45–RPM
RECORD ADAPTOR

ART CHANTRY

I have a small collection of 45 adaptors in a dozen different designs. Some are metal, some are red, some are crossbars, and some are plastic. This yellow spiral design outlasted all its competitors—a silent battle that raged for decades. This design is the final victor, delightful in its elegance.

The key to its success is its simplicity and reusability. It is the adaptable adaptor. Its yellow design can be spotted in an instant. Its simple spiral spring will last forever. It prevailed just in time for the extinction of the 45 records. Excellent timing.

SEAN ADAMS, ADAMSMORIOKA

For anyone born before 1980, the 45 record adaptor is a beautiful, useful object. I remember desperately searching for these things and, when I could not find one, fruitlessly trying to center a 45 record on a turntable. It rectifies the bizarre design of the giant holes on 45s. Did anyone consider standardizing the hole size of 33-, 75-, and 45-rpm records? In multiple pleasant colors, it's also easy to spot when it lands under the bed or when you're in a daze. To prove its value even today, I curse the world every time I pull out that Go–Gos 45 of "Our Lips Are Sealed"/"We Got the Beat" because I no longer own one.

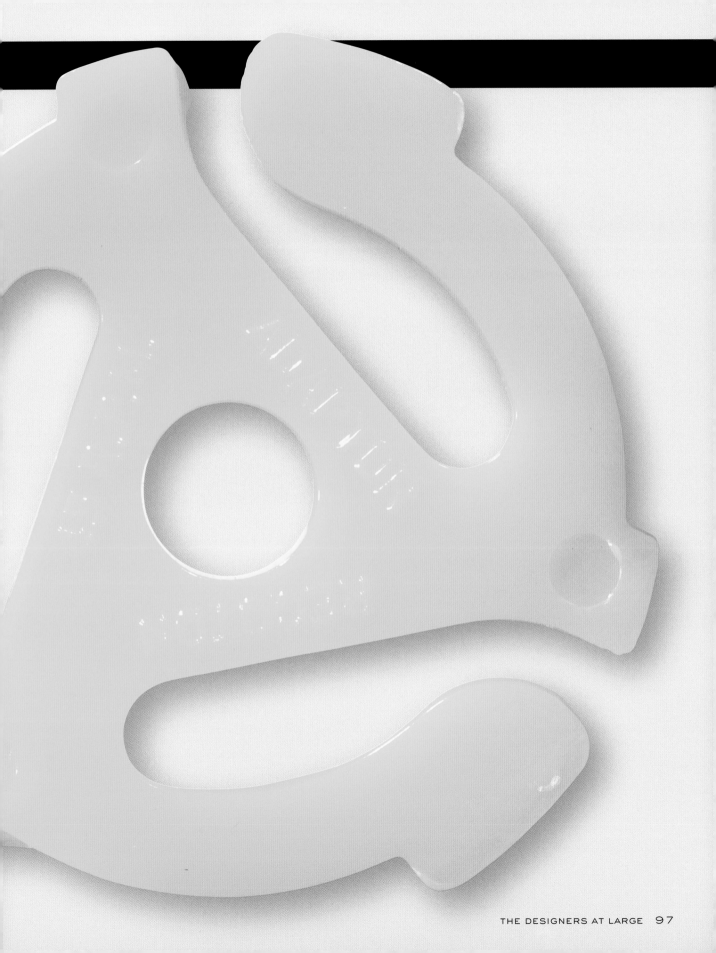

INTERVIEW:

Clement Mok

The Office of Clement Mok

San Francisco, California, USA

Much of **Clement Mok's** works are landmarks on the American design landscape, beginning with his work in the early days of Apple Computer as designer on the Mac's launch. Next, Mok launched his own design practice and began building an independent legacy of work that has its own monuments and design classics. In tandem with a design consulting business, Mok started a stock-photo business and a website-authoring software business, NetObjects Fusion. After a merger of his consulting business with Sapient at the peak of the dot-com years, Mok left in 2001 to begin anew his own concern: The Office of Clement Mok. His roles include president of AIGA National and design-planning management consultant. His expertise is not only terrific graphic design but also product development and launch and all that it encompasses, including strategic planning, channel marketing, and supply-chain management.

HELP US DEFINE GOOD DESIGN. WHAT DOES THAT PHRASE MEAN TO YOU?

When I got my training at Art Center in Los Angeles, the focus was discovering the concept behind the way something looked. It wasn't until my job at Apple that I realized design is really more about intent than about the execution or visual aspects. Today, I believe good design must have intent: It must give meaning to things. It could involve a complete new way of looking at things. For example, it could include designing a better process for search engines. Design touches everything. So to me, design is about discovering new ways of thinking; it's not just the visual quality (or lack thereof) of artifacts.

EARLY PACKAGING FOR APPLE'S MACINTOSH PRODUCTS DESIGNED BY CLEMENT MOK DEMON-STRATES APPLE'S KEEN AWARENESS OF GOOD DESIGN AS A SALES TOOL.

So if good design is intent and thought, who cannot be called a designer?

Everything around us is being designed by people who don't call themselves designers. So is it an education? Is it a title? Or is it really about possessing the skills acquired through training or experience and applying them in a way that explains or informs? But I do think to be taken seriously our culture requires that we are able to explain our point of view. For example, say you are attracted to a genre of music, ska, rock, whatever. But you don't know much about it.

It is not until you have the lexicon and taxonomy that you can begin to identity aspects of them and take note of them. Then you can appreciate them. Then you can discern what is good and what is bad.

So experience gives us the critical skills we need to judge?

Well, I don't remember who once told me this, but I never forgot it: "Like has nothing to do with it."

ABOVE AND OPPOSITE: THE MODIFED MACPAINT MANUAL CIRCA 1983 DESIGNED AND WRITTEN BY CLEMENT MOK AND SUSAN KARE.

Design has nothing to do with liking it. Design is a way of servicing the needs of others. Yes, part of you can be expressed through your design, but in the end, design is not about you. It is about you serving others. If something is beautiful, luscious, gorgeous—but has no utility, it is nothing but pure waste and extravagance.

DO YOU BELIEVE TOO MUCH DESIGN CONTRIBUTES TO PURE WASTE—AND IF SO, WHAT RESPONSIBILITY DOES DESIGN HAVE TO PREVENT IT?
I think society is nearing the end of the "culture of consumption." The green and sustainability movements are making a lot of existing design solutions look dated. This, of course, is a great opportunity for new ideas and new solutions. For example, do we really need that extra box or extra wrapper to make a product more compelling? If you do, can you do it differently? Old, established cultures only give way to new ones when assumptions are questioned then brought down by effective, new ideas.

HOW DO YOU CHALLENGE YOUR OWN ASSUMPTIONS IN ORDER TO IMPROVE?
Everyone relies on a bag of tricks. We are all creatures of habit. Over the course of my career, whenever I felt that habit was getting the best of me, I tried to enter a medium about which I knew absolutely nothing, where I had to puzzle out new constraints and rules. This is how I've learned to be a better designer. If you learn new constraints and rules, you can apply those lessons to the way you look at graphic design or any other design discipline you are comfortable working in.

CAN YOU NAME SOMETHING THAT YOU CONSIDER AN EXAMPLE OF DESIGN THAT MATTERS, DESIGN THAT HAS INTENT, DESIGN THAT COMMUNICATES?

Yes. The first MacPaint manual in 1983. Apple's first attempt at a manual about drawing ended up being 150 pages of nothing but text. It was crazy. And it was about to go to print. Instead, Susan Kare and I rewrote the entire thing, reducing it from 150 to 24 pages (excluding cover) with text, pictures, and graphics. We used pictures to show people

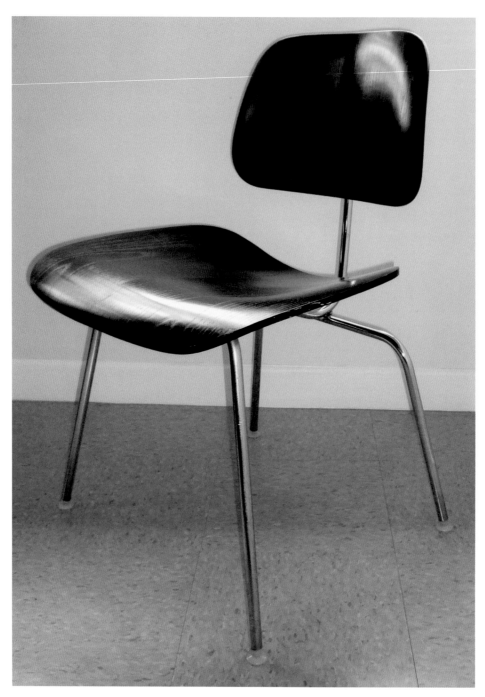

ONE OF THE MANY MOLDED PLYWOOD CHAIRS EAMES DESIGNED MIDCENTURY—ORIGINAL
PIECES FETCH A PRETTY PENNY THESE DAYS.

how to draw using a bar of soap. Our solution combined the mediums of information design, photography, and new technology to make Apple's new technology understandable. This was significant.

IT SEEMS LIKE YOU HAVE ACCOMPLISHED A LOT. DO YOU HAVE ANY UN-FULFILLED ASPIRATIONS? WHAT OTHER GOOD DESIGN WOULD YOU LIKE TO BRING TO AN AUDIENCE?

I would love to design physical product. Tables, chairs—these types of items for mass consumption. But if I did, they would have to be produced with sustainable design and practiced goals. They would have to be green. And it would have to be about making a positive impact on people, making their lives better, like Charles and Ray Eames did. Life is short. So I encourage anyone to figure out what they can do that will have the greatest positive impact for the greatest number of people.

"SOMETIMES, SUCCESS IS BEING IN THE RIGHT PLACE AT THE RIGHT TIME. BUT MORE OFTEN, IT IS ABOUT SEEING AN OPPORTUNITY AND GOING FOR IT."

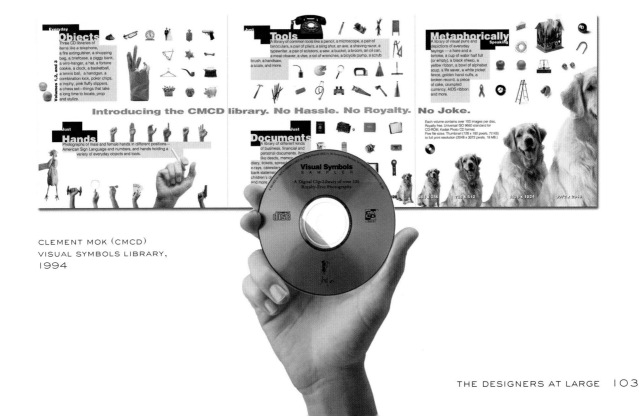

CLEMENT MOK (CMCD)
VISUAL SYMBOLS LIBRARY,
1994

Ulhas Moses
UMS
Mumbai, India

Ulhas Moses of Ulhas Moses Studio in Mumbai, India, has a particular interest in book design and other print design for which he has been awarded many worldwide prizes. Vivid, lush, mystical—the work of UMS often has a painterly quality, using vibrant colors, brushstrokes, splashes, explosions, intersections, and intricate line work. The work achieves an aesthetic level that has few peers. It is grounded in ancient Indian symbolism and traditions reinterpreted for application. If the work defies description or category, it is because it is multilingual. His approach is the foundation for superb work that travels far, far beyond the borders of India, to communicate with audiences in many places who speak many languages. A polyglot? No. Moses is universally articulate, significant, evocative, and real.

YOUR WORK DEFIES INTERNATIONAL CLASSIFICATION. FROM WHOM DO YOU DRAW YOUR INSPIRATION?

Foremost, Japanese designer Kohei Sugiura. For more than five decades, Sugiura has been a revolutionary innovator in every aspect of design. He is the rare Grand Master, with a prodigious body of work that spans the entire field of design, from books, editorial, typography, postage stamps, periodicals, posters, and environmental and information design. The work is uniformly remarkable, but its most distinguishing feature is the striking clarity of his design vocabulary, conflating emotion, logic, and foresight. He is always ahead of the times. He is also an intellectual, with extensive writings on perception, visual communication, and iconography with a special focus on the cultural traditions of Asia. He has had a profound impact on design thinking for an entire generation of designers across Asia.

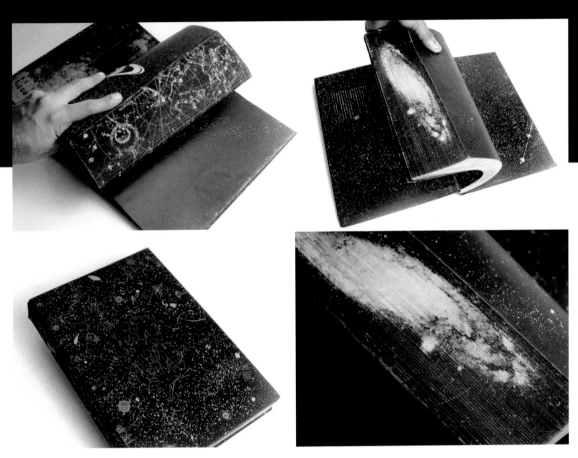

BOOK COSMOS SUMMA COSMOGRAPHICA BY KOHEI SUGIURA

This stunning example of design dedication and craft, *Book Cosmos*, designed by Kohei Sugiura, is the fruit of nine years of labor. He juxtaposes text and stardust against a jet black background to suggest the cosmic contest between order and chaos, the physical and conceptual. His images dance off every page—carrying readers off on a personal space odyssey. Depending on the way one slants the page, its trimmed edge reveals both the Andromeda galaxy and Flamsteed's chart of constellations.

IN YOUR OWN COUNTRY, TO WHOM DO YOU LOOK FOR DESIGN INSPIRATION? The late Indian calligrapher and typographer R. K. Joshi has also profoundly influenced my thinking and design. He created typefaces for fourteen major Indian languages, developing font design software, Indian language word processing packages, and Indic fonts for

TYPOGRAPHIC TREES BY R. K. JOSHI. IN THESE POSTERS, THE TYPEFACES (DEVNAGARI, SANSKRIT, GURMUKHI, TAMIL, AND BENGALI) COME ALIVE TO FORM TREE PATTERNS.

Microsoft Windows and Linux. I am inspired by his legacy of significant exhibitions, workshops, and seminars on wide-ranging aspects of Indian letterforms. Joshi's revolutionary calligraphic works brought attention to Indian manuscripts and epigraphic writings featured at many educational institutes and public forums. He was a poet. He also staged multilingual events, developing the first-ever multilingual communication campaign. The list of this man's accomplishments is not simply impressive—it is mind boggling.

WHAT OTHER DESIGNERS HAVE INFLUENCED YOUR CAREER?

Milton Glaser, the American icon of graphic design and one of the most accomplished and celebrated graphic designers and illustrators ever known. Glaser's work is direct, simple, and original—the very definition of good design principles. He can solve communication problems in any medium, with styles that veer wildly from primitive to avant garde and which can be observed on countless book covers, album covers, posters, and editorial contributions. When you see his work, you witness a range and randomness that makes it hard to believe it was the invention of one man. His impact on contemporary illustration and design is immeasurable.

A European designer who I admire is Niklaus Troxler. His delightful, colorful jazz posters are layered with visual puns and musical metaphors executed with handcrafted and skillful illustration and typography. Troxler deploys silk screen and lithography to communicate figurative and abstract ideas in the form of paper cutouts, collage, stencils, and brush and line drawings. Remarkable, cross-disciplinary work.

You are an accomplished publication designer. Typography plays a tremendous role is this genre of design. Can you name a typography and font design group that you consider at the top of the game?

Emigre Graphics, founded by Rudy Vanderlans and Zuzana Licko, without question. It was the first internationally recognized font creator that had no association with a typesetting equipment manufacturer. Throughout the '80s and '90s, their team of designers electrified designers around the world with the most cutting-edge typefaces ever seen. Showcased through its legendary magazine of the same name, Emigre demonstrated the potential of not only typeface design, but of all kinds of graphic experimentation.

Your design incorporates a great deal of fantasy, mysticism, and visual storytelling. Who delights your vivid imagination?

Yoshie Watanabe, lead designer at Tokyo's Draft Co., unsurpassed in her talent for creating whimsical, intelligent design solutions. I recommend others take a look at her work—

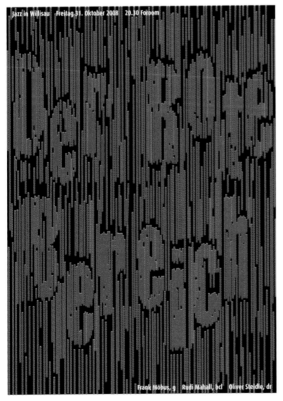

POSTER DESIGNS BY NIKLAUS TROXLER

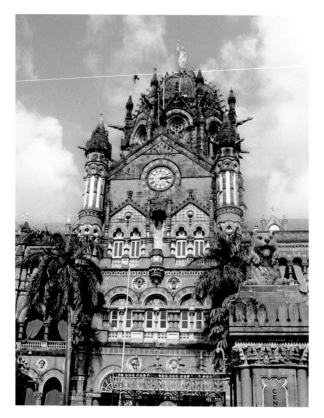

MUMBAI'S CHHATRAPATI SHIVAJI TERMINUS

NIGHT LIFE OF TREES BY TARA BOOKS

WOODEN TORTOISE DESIGNED BY
YOSHIE WATANABE OF TOKYO'S
DRAFT CO. WHEN THIS DELIGHT-
FUL WOODEN TORTOISE IS PULLED,
THE WHEELS (LEGS) CAUSE THE
LARGER BALL (SHELL) TO MOVE
TOO, CREATING A KINETIC OPTICAL
ILLUSION.

delightful, amusing designs of greeting cards, books, products, often bearing her signature "fairy-tale" effect.

Indo-Saracenic architecture is a synthesis of Muslim, Hindu, and Gothic designs developed by British architects in India in the late nineteenth and early twentieth centuries. This architectural style combines elements of Hindu and Mughal architecture along with Gothic cusped arches, domes, spires, tracery, minarets, and stained glass in a wonderful, playful manner. Indo-Saracenic architecture has found its way into public buildings across India.

Inspiring, intricately drawn visions of trees fill the pages of this sumptuous book of art and folklore from the Gond people of central India. In Gond belief, trees stand in the middle of life, and the spirit of many things lie within them, busy all day, giving to all shade, support, shelter, and food. When night falls, they take rest and then, under quiet dark skies, the spirits are revealed. This image was re-created from original art by the finest living artists of the Gond tradition. Each painting is accompanied by its own poetic tale, myth, or lore—narrated by the artists themselves, re-creating the familiarity and awe with which the Gond people view the cosmos.

HOW DO YOU EVALUATE THE WORK OF OTHERS?

When encountering another person's design, I examine the language to see how he or she weaved symbols and iconography to tell a story and give it meaning. This permits me to glimpse into his or her thinking process and personality. It is also interesting to note the social and cultural conditions that were responsible for a particular piece of design whenever you can. All this provides context.

THIS DOOR ENVELOPE AND LETTERHEAD IS AN EXCELLENT EXAMPLE OF DESIGN CRAFT THAT DELIGHTS THE SENSES.

YOU HAVE ACCOMPLISHED SO MUCH. WHAT ADDITIONAL ASPIRATIONS DO YOU HAVE TODAY?

The focus of my practice is innovation and combining the energies and sensibilities of "Art + Craft + Design." Art deals with heightened emotional responses, intuition, perception. Craft deals with skill, understanding materials, and techniques. It has a lot to do with working with one's hand to lend the human touch (soul) to the work. Design is about creating order, the encoding of signs, information, structure, typography, and the manufacturing process. I seek a balance between these elements as I fuse contemporary design with Indian symbolism. Indian art and philosophy can give form to the formless and explain the most complex metaphysical ideas. I draw from this rich symbolism and interpret it in a contemporary design context in my work, with the hope of creating a new Asian design grammar.

CHILDREN OF THE BALWADI BY ULHAS MOSES FEELS AT ONCE MODERN AND PERSONAL, SLEEK AND TACTILE, MARRYING IMAGES AND COLOR FOR AN EMOTIONAL RESPONSE.

Ensi Mofasser might not be a household name in the USA (yet), but she has quite a following in Iran and Sweden. Of Iranian and Swedish descent, Mofasser designs for some of the largest businesses in the world, using an impressive array of design platforms and crossing many disciplines. Hers is a world-class and impressive body of work.

WHO DO YOU LOOK TO FOR CREATIVE INSPIRATION? PLEASE DO NOT SAY PAUL RAND.

My six-year-old cousin is the most creative person I know. He is always drawing or cutting and pasting or gluing. In his quick designs he is so clear and descriptive that I am often left dumbfounded. He never adds a single extra flourish. It's so simple. I think designers are often so busy trying to win awards or impress the boss that we forget to—or do not dare to—show our most instinctive, simple solutions.

YOU ARE SKILLED IN MANY DESIGN TECHNOLOGIES. DO YOU PLACE A HIGH VALUE ON CROSS-DISCIPLINARY DESIGN THAT REQUIRES CROSS-PLATFORM TECHNOLOGY?

Certainly. Communication leaps across media at the speed of light. I think every designer should cross disciplines. Not only to gain a broader understanding of brand challenges, but also because combining technologies and skills is a powerful approach. It is also more fun, motivating, and challenging to approach a common challenge in an entirely new way. Good designers know how to twist their brain in order to think in new dimensions, achieve greater depth, and add distinctive layers. Think nonlinearly. It will keep you and your work refreshing, challenging, and fun.

THESE ARE IMAGES FROM ENSI MOFASSER'S TRAVELS. LARGELY PACKAGES AND SIGNAGE, THEY INFLUENCE HER DESIGN. "TRAVELING AND ENCOUNTERING SO MANY WONDERFULLY DIFFERENT CULTURES, VALUES, BELIEF SYSTEMS, AND AESTHETICS TEACHES ME HOW MANY VARIOUS WAYS THERE ARE TO LOOK AT THE WORLD."

WHAT MOTIVATES YOU TO KEEP ON GOING AND GOING UNTIL YOU NAIL THE SOLUTION?

I love the search for the single right idea. It's like tennis, which I enjoy a lot. When you finally manage to hit the ball perfectly, it makes a beautiful noise and the ball returns to the opponent's side of the court gracefully. It looks effortless. When the single right idea reveals itself after a long search process, it feels like perfect tennis, but even better. It is so rewarding and motivating.

IS THERE A PLACE FOR PRETTY PICTURES IN DESIGN?

In the pages of the Pantone swatchbook. It is so pretty and pleasing to look at.

WHAT DOES GOOD DESIGN DO BEST?

It communicates quickly and easily. It is easy to read. Personally, I hate being forced to read a lot of copy. When it comes to a package, a website, or an advertisement, I want to get the information in the fewest words possible.

The beauty of these packages lies in the style of the illustrations, the boldness of the silhouettes, the rough printing process that lets you see the aged craft, the use of flat primary colors, and the wonderfully crafted typography. But what makes these especially interesting is the size of these designs. The use of space on these tiny boxes and the amount of detail and care put into them make them remarkable pieces of art. That little box captures a moment in time, and brings us a piece of history.

AT THE END OF YOUR LIFE, WHAT DO YOU WANT PEOPLE TO SAY ABOUT YOUR WORK?

I hope they say that I have created a little goodness and made this world a shade brighter. I want them to say that Ensi used her skills to create and spread positive and important messages. That is the hope of any good, responsible designer.

ENSI MOFASSER'S EFFORTS RECENTLY HAVE LEANED TO THE ALTRUISTIC. THE PROCEEDS FROM THESE T-SHIRTS HELP FUND MEDICAL EFFORTS FOR CHILDREN IN INDIA.

WINE KEY

HENRIK PERSSON, BECOME

The wine key is developed to serve a specific purpose and to solve a problem. Good design solutions often originate from a clear problem, and in this specific case it is very obvious. The inventor/designer must have thought, "Here is a bottle of wine; it is sealed. I've got two hands with five fingers to help me—but that doesn't get me far. I need a tool!" Possible thoughts that went through the head of this same person:

1. "I need to get rid of that foil around the bottle-neck. A tiny little knife/saw would do this job!"

2. "Now, how do I get the cork out that is stuck inside the hole? I need something to attach to the cork so that I can pull it out—a drill!"

3. And then after creating the first prototype, another problem occurred: "This was heavier than I thought. I need something to help me to pull the cork out, something that holds the bottle down whilst I drag the cork upwards..." And then the last step toward a complete functional tool was invented.

4. Finally, the designer shaped the handle to fit comfortably into my hand. He/she also made it pocket size and made sure that no sharp items were sticking out when the tool was unfolded. This is a brilliant design solution. Perhaps this particular brand/version isn't the best-looking one, but the form in this case is secondary to the functionality.

JOEL NAKAMURA

I like it. I want it. It can't get better than that. It's impulsive, which is what you want in a novelty product.

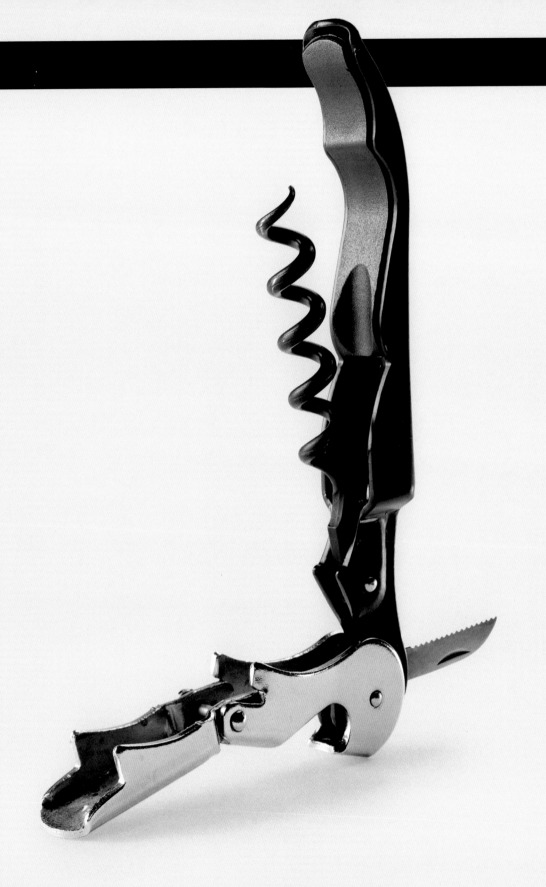

THE DESIGNER, THE CHICKEN, AND THE EGG

According to many of the people who participated in this book, when form precedes function, design fails. But this perpetual chicken-egg question has troubled honest designers for ages.

So let's address it. Design is a commercial endeavor. It's supposed to meet a need. "Success" (good vs. bad design) can be measured. For the sake of argument here, let's call *form* the Chicken and *function* the Egg. The Chicken, then, must follow the Egg.

Does this mean one should follow function slavishly so that form is never a factor in the look of the Chicken? Lord, I hope not. No, the most successful design reveals personal choices and insights. It can be distinguished by a distinctive style, voice, or signature. The creative process generates tensions. It forces us to compromise and punishes pigheadedness. It creates give and take that leads to unique, effective solutions. If not unique, at least honest.

This is where soul comes in. Now, whether soul is present at the Egg's conception or at the Chicken's birth is a question for another day. But soul is part of the discovery process. It originates from the designer's point of view. It is shaped by her personal experiences. It is the product of knowledge. It is the 99 percent intuition that Rand spoke of.

Eduardo Barrera's poster work has represented Mexico in official selections and biennials in eighteen different countries. A freelance graphic and publications designer since 2001, Barrera has worked for *Lúdica, Viceversa,* and *Expansión* magazines as well as the National Fine Arts Institute, the International Biennial of the Poster in Mexico, *La Jornada,* Richmond Publishing, Turner Libros, Mateus Books, and with Eveun creative boutique for Televisa and *Fashion Week,* among others. Prior to freelancing, he was the art director at Leo Burnett Mexico and creative director of the Magic Moments advertising agency in Vienna, Austria.

A SAMPLE OF WIM CROUWEL'S TYPOGRAPHY

WHO ARE THE MOST LUMINOUS LIGHTS IN YOUR DESIGN SKY?
Well, let's start with Wim Crouwel, the master designer and typographer from Holland. His fonts, particularly New Alphabet, made in 1967 for the Stedelijk Museum in Amsterdam, are designs I have long admired. He was truly ahead of his time, designing extremely modern characters with superb legibility and functionality. But despite their geometric perfection and harmony, they are not appropriate for just any design subject. They seem perfect for an electronic music

flyer or a high-tech gadget company. I cannot possibly imagine New Alphabet on a poster for a Shakespeare play.

Another example I always point out to students is the legendary work of the Italian architect/ designer Gaetano Pesce. Look at his UP 2000 furniture series for B&B Italia. With it, the designer solves first the issue of function—the seats are very, very comfortable. Then he addresses form with beautiful materials and production quality. Perfection. Then he adds a strong political statement to the UP5 and 6 by representing a subjugated woman with a ball chained to her ankle; [this was] back in the heyday of the women's liberation movement. Aesthetically, the result is not only contemporary, but timeless. It was an instant classic.

These days, I especially like the poster work of Ralph Schraivogel. His typographic compositions are playful and intelligent. They arrest the eye. He is, I think, way beyond the illegibility experiments by people like David Carson, which I liked when I was younger but whose style I grew weary of very quickly. With Schraivogel, the poster designs don't belong to any visual tendency, past or present. They have an analog sensibility, generating strong impact and making them impossible to ignore. They invite you in to see and read them. Sometimes, he uses images, sometimes photographs, sometimes merely type. This unpredictability is perhaps his greatest virtue.

Do you think designers can cross disciplines?

I certainly do. I have been working lately with a variety of contemporary visual artists. It seems nowadays artists are looking more at how their art can be produced in offset or digital printing: posters, publications, billboards—formats that traditionally were exclusive to the graphic design field. Some of them are even learning graphic design techniques to accomplish such work. I recently designed a piece with the artist Erick Beltrán, whose idea was to create a newspaper he calls Ergo Sum with 320 pages showing thousands of images and texts in which he is interested: philosophy, politics, bizarre news from different parts of the world, science, etc. I convinced him to do something he had never done before with his publications: to use design to establish the relationship between the many images he h ad selected so that the piece would not be perceived

only as the catalog of a manic, random image collector. Instead, the work reveals an intricate matrix of concepts and their relationships. This navigation system became so important to the understanding of the publication that my collaboration became a coauthoring. Crossing disciplines can be extremely enriching and educational. I encourage all designers to broaden their horizons.

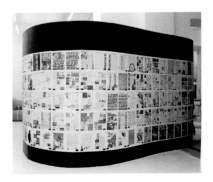

THE MOTIVATION OF DESIGNERS IS NEVER THE SAME FOR ANY TWO. WHAT ARE YOURS?

I have many. For example, I am motivated by work that feeds my soul and also by money. Sometimes these are in conflict—sometimes they are not. Cultural design work is always welcome because I learn about literature, theater, music, and other things that I appreciate. And such work can be challenging: a poster for a classic opera or theater play such as Aida or King Lear is hard because so many great designers before me have already done it. To be good, the design must be the umpteenth visual interpretation of a text that everybody knows, but dare not resemble anyone else's classic image from the past. That kind of challenge will motivate any good designer—or drive them mad.

THE *ERGO SUM* PROJECT

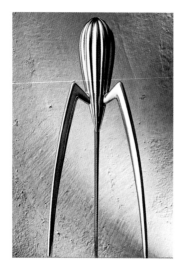

PHILIPPE STARCK LEMON JUICER

IS THERE AN OBJECTIVE WAY TO JUDGE WHAT GOOD DESIGN IS? HOW DO YOU EVALUATE YOURS?
Compare it to the best. Buy and study author-retrospective books or books on specialized subjects, such as independent film posters or twentieth-century type. Compare your work to this work. Will your work inspire awe? Will it command attention and respect? Be honest. Be hard on yourself. Get your own work measured by the highest standards: What would Paul Rand say about it?

THERE'S THAT GUY AGAIN. ANY OTHER NAMES YOU WANT TO DROP IN THE CONTEXT OF WHAT MAKES GOOD OR BAD DESIGN?
I confess I actually bought a Philippe Starck lemon juicer. What an expensive piece of shit. It looks great, and when you see it in the store, it makes sense: The juice will flow through the canals and drip directly in the glass. Only it doesn't work. First, you find a notice in the box telling you that you have to wash it immediately after using, or the lemon's acid may damage the finish (brilliant choice of materials!). And since it has three legs, when you squeeze a lemon in a normal, twisting motion, it falls to one side or another. Finally, the juice runs everywhere but in the glass. It doesn't work. So it is nothing but a nice sculpture that wanted to be a useful kitchen appliance. Superstar designers make crap, too.

WHAT DO YOU HOPE TO ACCOMPLISH IN YOUR LIFE IN DESIGN?
I'd like to earn a place in the history of design. I'd like to be remembered for the quality of my work. I will teach more, and hopefully not at a single place, but traveling around. I'd love to be a design wiseman who writes texts that people find interesting when I'm dead. I hope I live to see the time when graphic designers are not exploited. I hope to lead younger designers to answers it took me fourteen years to find. Still a long way to go, I hope.

EDUARDO ARAMBARRI SPEAKS LOUDEST PERHAPS IN HIS
POSTER WORK, AS SEEN HERE.

Michael Hodgson leads Ph.D—the Los Angeles design firm is widely known for its intellect, skill, and creative versatility. An Englishman by birth, Hodgson is now a fixture in the L.A. design scene, known for his wit and youthful exuberance (which belies his age). Over the years, Hodgson has learned how to balance work and life by pursuing opportunities that allow his skillsas a designer to make a difference in the lives of those around him. His trade is his design. His gift is giving generously of his time and talent.

WOULD YOU NAME A FEW DESIGNERS WHOM YOU REVERE?

I am inspired by many things—great design, clothes, music, movies, my kids, the designers in my office, Reynolds Stone, Paul Landacre, Matteo Bologna, Fausto Coppi, Ian Dury, Miles, Paul Weller, Lucca, Fat Tyre, Viogner, Prosecco… I could go on. But permit me to provide three examples of individuals whose work set new standards.

First, fashion designer Paul Smith. I love clothing, and his work is always moving forward. He is never content to settle on one idea. He will not yield to the temptation to keep producing the same thing year after year. I like his "Classic with a Twist" approach: beautiful elegant suits with a bright floral lining or one cuff button a different color from all the others. He seems to suggest a love for apparent mistake—which is, of course, no mistake but completely by design. He is a craftsman who loves to delight and surprise his audience. Good design does this.

Second, I have always respected and admired the work of the late Tibor Kalman. He consistently questioned what was right—what was expected, appropriate, or predefined.

"[PAUL SMITH] IS A CRAFTSMAN WHO LOVES
TO DELIGHT AND SURPRISE HIS AUDIENCE.
GOOD DESIGN DOES THIS."

PAUL SMITH'S CLOTHING
CONTAINS HIDDEN DETAILS
THAT DELIGHT CUSTOMERS.

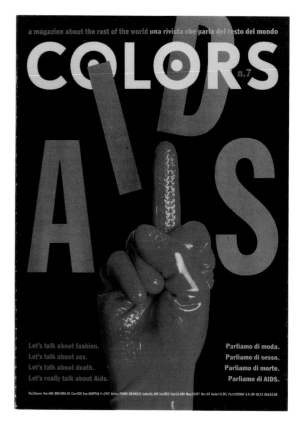

TIBOR KALMAN'S POWERFUL AND GROUNDBREAKING
WORK FOR *COLORS* MAGAZINE

He designed what he thought was the best for any project, sometimes taking the exact opposite direction the client or anyone else would have expected. He was courageous and broke rules. Good design does that, too.

Third on this list is the enduring work of Charles and Ray Eames. They were so good at so many things, not just furniture, architecture, and film, but also producing far-reaching and thoughtful studies such as the "The India Report," which they prepared at the request of the government of India. Over the course of a three-month visit to India in 1958, Charles and Ray explored the problems of design, handicrafts, and manufacturing. When it was submitted in 1961, the report highlighted the Eames' critical recommendations for the development and improvement of design training that could aid the nation's small industries. In response, the Indian government established the National Institute of Design to focus on research, service, and training in industrial design and visual communication. When we speak of designing for a social good and effecting positive change today, we should note that Charles and Ray were at the vanguard of this notion more than fifty years ago. Great designers reach beyond their limits to achieve great things.

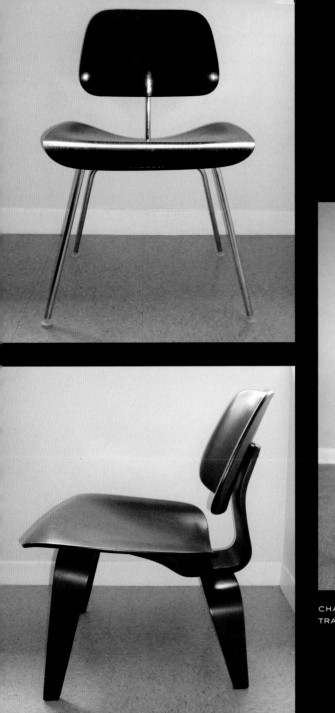
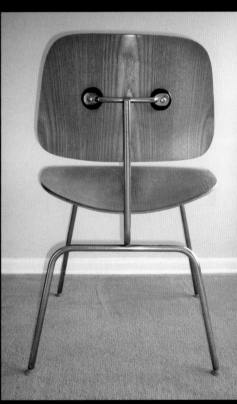

CHARLES AND RAY EAMES' FURNITURE DESIGNS
TRANSCEND TIME AND THEY WERE BUILT TO LAST.

MICHAEL HODGSON'S PENCHANT FOR A TWIST AND WIT SHINE IN HIS WORK HERE, FOR THE
ROSENTHAL THEATER AND THE AIGA'S GET OUT THE VOTE.

THOSE THAT YOU MENTIONED HAVE FOUND SUCCESS ACROSS MANY DIS-
CIPLINES. WHAT VALUE DO YOU PLACE ON CROSS-DISCIPLINARY DESIGN?
Great designers can move out of their comfort zone in order to bring new thinking to resolve
old problems. There is no such thing as a new problem. There are only new solutions.

WHAT IS YOUR GREAT MOTIVATOR?
I love the challenge of problem solving. This does not mean simply making something
look good. It means making a solution function more effectively than ever before. A goal I
keep foremost in my thoughts—to design a few things that people will look at in fifty or a
hundred years and say, "Wow, I love this!"

YOU MENTIONED THAT YOU ASPIRE TO CREATE WORK THAT OTHERS
WILL ADMIRE YEARS FROM NOW. OTHER THOUGHTS ON YOUR CAREER
ASPIRATIONS?
Any good designer hopes in some way to make things that improve the lives of those
around them—family, friends, associates, clients. One way I think all designers can do this
is to educate themselves and their clients about sustainable business practices and find
solutions through design that takes them there.

Fumi Watanabe is the creative manager at Starbucks in-house design department in Seattle. Her work is regarded as uniformly brilliant while visible all over the world. Watanabe is as skillful at illustration as she is at graphic design. In addition to Starbucks shops worldwide, some of her work is for sale by IKEA. Not yet a household name in world design circles, Watanabe soon will be.

WHO ARE YOUR HEROES OF GREAT DESIGN?
Charles and Ray Eames were the original design-for-everyone masters who have left behind a great legacy of timeless yet innovative designs. I also like that they made play a part of their business practice.

HOW DO YOU DEFINE GOOD DESIGN?
The best designers work across different disciplines. This helps them create solutions to problems that are not formulaic. It helps to think beyond the limits of one design discipline in order to come up with the best solution. I like to work on multifaceted projects with multiple components that require multiple disciplines to tell a complete and cohesive story.

I find good design in easy-to-miss places, like this speaker grille, the relief pattern, and even chopsticks for their simplistic functionality.

WHAT MOTIVATES YOU TO FIND THE BEST SOLUTIONS?
Working with talented, cross-disciplinary people. Discovering the client's needs early in the development process. I view myself as part visual consultant, part detective/sleuth.

"I FIND GOOD DESIGN IN EASY-TO-MISS PLACES, LIKE THIS RELIEF PATTERN, SPEAKER GRILLE, AND EVEN CHOPSTICKS FOR THEIR SIMPLISTIC FUNCTIONALITY."

Problem and puzzle solving is interesting and motivating to me. Through that detective work, a concept will reveal itself. When it does, it feels so good.

BUT HOW DO YOU KNOW THAT YOU HAVE FOUND THE BEST SOLUTION— HOW DO YOU KNOW WHEN A DESIGN IDEA IS NOT JUST GOOD ENOUGH?

You must seek the unconventional solution, the one that cuts through the existing frame of thinking. You must evaluate your solution against the client's initial goals and your own sense of design excellence. That means your personal standards must be very high in order to ensure that your solution is not boring or predictable.

WELL, WHAT KEEPS A DESIGN SOLUTION FROM BEING BORING?

Different visual problems require different solutions. The best design solution is often so natural, so intrinsic, that it's invisible. However, the solution that catches my attention is often the one that has an element of play in it. Often, this is the very thing that drew the client to my work in the first place.

DOES PRETTY OR PLEASING DESIGN HAVE A ROLE TO PLAY IN THE DEFINITION OF GOOD DESIGN?

Design has many definitions. Pretty is as legitimate as any, if appropriate to the need.

YOU MENTIONED THAT ONE OF THE PRINCIPLES THAT YOU LIKED ABOUT CHARLES AND RAY EAMES WAS THEIR SENSE OF PLAY. BUT ISN'T DESIGN A SERIOUS BUSINESS REQUIRING SERIOUS PEOPLE?

It is a fun business that attracts talented people. In my opinion, play—or a sense of playfulness—motivates and inspires. I need to feel that sparkle of excitement in every project to inspire me to find the best design solution. I need to maintain a high level of passion and standard for excellence in even the smallest project.

FROM WORK SOLD AT IKEA TO PRODUCTS AND MUSIC PACKAGING, FUMI WATANABE IS FLEXING ALL OF HER CREATIVE MUSCLES WITH SEEMINGLY LITTLE EFFORT.

ALUMINUM BOTTLE

Josh Higgins

I like this because it can be recycled and resealed. It won't break or leave glass shards to step on. It serves as its own label. The color and the aluminum together look fresh. I used one of these on a river raft trip once, placing it in a mesh sack that was tied to the raft and dropped in the water to keep it chilled. Every time I pulled it up for a drink, it had a few more dents, but—thankfully—beer doesn't bruise. Perfect.

Ulhas Moses, UMS

The bottle form is nice—a slender departure from the usual beer bottle shape. Does the change in materials affect the taste of the beer? If not in reality, what about in perception? How can a new material, new shape, new design affect consumer perceptions?

Paul Sahre
Designer/Educator
New York, New York, USA

Paul Sahre (s-air) is more than a graphic designer. He is a popular teacher at New York's School of Visual Arts and a contributor to the *New York Times* editorial page and *Book Review*. In addition, he is a renowned theater poster designer, a published author, and a provocative conversationalist and thinker. He celebrates the world's contradictions, dialectics, and strange bedfellows. He toils two stories above a Dunkin' Donuts store at 6th Avenue and 14th Street in Manhattan. He is still trim. But he drinks a lot of coffee. Sahre is a member of the esteemed Alliance Graphique International based in either Far Rockaway Beach or Paris, depending who you ask. In this interview, he turns the premise of this book upside down.

PAUL, WHY DID YOU AGREE TO BE INCLUDED IN THIS BOOK IF IT WAS JUST GOING TO MAKE YOU MISERABLE?

Only after agreeing did I realize that I have a problem with viewing design as either good or bad. Of course, I know what I like and I know what I don't like, but this is not the premise of the book. Instead, I gave careful consideration to questions such as:

• When you see good design, what is it that is appealing to your senses, your intellect?
• Tell us about some designer you most admire and why.
• What are your red flags for bad design?

But to my surprise, I could not answer a single question, and I found that I could not come up with any examples of something that I could definitively put in either "good" or "bad" categories. I had a problem with the premise—that one could argue the relative goodness or badness of anything designed. So instead, I selected a handful of objects and wrote about what I thought was good and bad about them.

1. THE WIFFLE BALL

This is a ball designed for playing baseball indoors or in confined areas—in my case, my parents' backyard. David N. Mullany designed it to help his son throw a curveball with ease. The ball is made of plastic and has a row of holes on one side that allows the pitcher to easily throw a variety of pitches, depending on how the pitcher holds the ball—just like in real baseball. But because of the asymmetrical holes, the ball's movement is much more dramatic than that of a real baseball. This Wiffle brand ball was the only ball we played with. Using another ball was out of the question.

The ball and the packaging have not changed since it was introduced back in 1953. Of course, as kids we never gave a thought to the aesthetics, but looking at the Wiffle ball now, it is a surprisingly beautiful object. I do remember liking the graphics on the box as a kid. It has a simple, functional approach: On four sides of the box the ball is pictured, and on the remaining two sides there are simple instructions for how to throw a curveball and a slider.

On the other hand, the Wiffle ball has a serious design flaw that was a constant problem for us kids. The holes that allow for the ball to be curved easily also create weak points between the holes where the surface area of the ball is at its most narrow. This meant for us kids that a new ball might only last one or two games before cracking. We, of course, would keep using it as long as we could. I remember this issue being a constant problem that we tried to remedy with glue or tape. Nothing worked. As far as I can tell, the manufacturers still have not resolved this flaw. Bad for the kids, but great for Wiffle Ball Inc. because there is a constant demand for new Wiffle balls. I don't remember what a Wiffle ball cost when I was ten years old, but at forty-four, I just bought one for $1.39 (£0.95). Cheap! Perhaps you can argue that the price was likely factored into the design flaw, but playing with an unbroken ball was a rarity.

The Wiffle ball might also be an example of bad design because the packaging is out of date. Personally, I love the packaging because it looks like it always has and it seems appropriate and honest. It was, however, designed in the '50s, and printed on it is the statement *The NEW Fun Ball Wiffle Ball*. A curious claim, since the Wiffle ball is fifty-plus years old. I am sure some branding or advertising agency has been telling them that they could sell another 500,000 of these things every year if they just updated the packaging. Consider other famous branding from that era: Wrigley's gum, Campbell's soup, and United Parcel Service. Good or bad?

"I DO REMEMBER LIKING THE GRAPHICS ON THE BOX AS A KID. IT HAS A SIMPLE, FUNCTIONAL APPROACH: ON FOUR SIDES OF THE BOX THE BALL IS PICTURED, AND ON THE REMAINING TWO SIDES THERE ARE SIMPLE INSTRUCTIONS FOR HOW TO THROW A CURVEBALL AND A SLIDER."

2. we/me BRAND

What do you do when you are trying to save the world? Apparently you use the same techniques that for decades have encouraged Americans to buy shit they don't need. You turn a nonprofit movement into a brand. In short, you employ the same branding strategies that the huge corporations use when they are using marketing research to reach me (and we) as a demographic, the approach that is at least partially responsible for getting us into such a mess in the first place.

I loathe this concept. It appears to be "green washing," even though it isn't. The We Campaign is a project of the Alliance for Climate Protection—a nonprofit, nonpartisan effort founded by former vice president Al Gore. How it actually communicates is questionable. I don't trust it. It is too sophisticated—too branded. It treats the environment like anything else we should consume, while at the same time, it points the finger at the individual for consuming! But the problem is not ME or WE. The problem is THEM: the BP's and Starbucks and McDonald's of the world. I can't help but think of the person at the grocery store desperately trying to find ways to help save the environment while buying his groceries—reusable shopping bag in hand—but having to fill this bag with branded packaging he doesn't want or need.

> "I HAVE TO BELIEVE THAT THIS MARK HAS BEEN SUCCESSFUL IN RAISING AWARENESS FOR THIS PROJECT. BUT I STILL WOULD NOT USE THAT FACT TO LABEL IT AS GOOD DESIGN. OR BAD."

Still, this is not an example of bad design, either. The we/me mark is simple and well designed. It's for a good cause. It's green, so we know it is environmentally friendly, right? It's typographically clever—the *m* in me also happens to look like the *w* in we when it's flipped. It is simple and memorable—all hallmarks of good design. It is clearly an attempt to communicate dual responsibility, the core of the project's message. I have no way of knowing, but I have to believe that this mark has been successful in raising awareness for this project. But I still would not use that fact to label it as good design. Or bad.

3. TO-GO COFFEE LID

This lid contributes to the massive consumption of coffee all over the world. It allows coffee to be served anywhere, on the go. Among coffee drinkers, the average consumption in the United States is 3.1 cups (725 ml) of coffee per day (bad?). In addition to preventing spills, the lid helps keep the beverage hot (good).

There are many different lids out there, but I focus on the one Dunkin' Donuts uses since they are downstairs from my office and I buy coffee from them almost every day. Now, is it just me, or does everyone have trouble with these? I estimate that I get malfunctioning lids at least 30 percent of the time. Often the lid flap—after it is peeled away—will not stay put in the lid top flap buckle (bad). This means every time you sip, this lid flap is poking you in the nose (bad). Also often, the seal between the cup and the lid is compromised, leading to hot coffee drips running down your hand (bad).

> "NOW, IS IT JUST ME, OR DOES EVERYONE HAVE TROUBLE WITH THESE? I ESTIMATE THAT I GET MALFUNCTIONING LIDS AT LEAST 30 PERCENT OF THE TIME."

Furthermore, the lid is not a thing of beauty unless, like me, you find beauty in places where function dominates aesthetics—like manhole covers or jet engines. This coffee lid is absolutely designed to be functional (good?). The worst thing about these lids is they are designed to be used by the customer only once, then tossed out with the cup. I am not up on coffee lid manufacturing, but I have to believe that these things are bad for the environment (bad).

4. BROOKLYN SUPER HERO SUPPLY CO. PACKAGING: 826NYC

826NYC is a nonprofit organization located in Park Slope, Brooklyn, that is dedicated to helping children aged six to eighteen improve their creative and expository writing skills while also helping teachers inspire their students to write. 826NYC is located in a secret lair behind the Brooklyn Super Hero Supply Co., which sells capes, grappling hooks, utility belts (new and vintage), masks, tights, deflector bracelets, bottles of chaos and antigravity, secret identity kits, and more (according to Wikipedia). This is the toughest item I've chosen to argue for its bad qualities. It is part of a line of products that benefit 826NYC. It was designed by Sam Potts, a good designer. It looks fantastic, employing a '40s hardware store aesthetic—which is close in feel to the Wiffle ball packaging mentioned earlier. But here, the aesthetic is purposely designed to look out of date—for an effect. It emphasizes a function that does not exist. I would argue that it is funny and poignant without trying too hard. The products are basically packaged ideas. The antimatter is a can of water, the gallon of invisibility is filled with air, etc.

"IT LOOKS FANTASTIC, EMPLOYING A '40S HARDWARE STORE AESTHETIC."

Now for the bad. These concerns were expressed online by observers, and some of the comments are directed at the store itself.

"Boring"

"Completely disappointing"

"My child cried for thirty minutes when he got it home and found out that it was a joke."

"Fun for about 5 minutes"

"All gift wrapping, but no gift"

"Clever (not in a good way)"

"High pretension factor"

"Who pays $10 or $15 (£6.5 or £10.4) for an empty container?"

Finally, I have mixed feelings about appropriation of this kind. I do it occasionally myself and always feel a little guilty about it. While I love it, I also believe that it is a designer's responsibility to make work that feels "of our time." But maybe this is of our time. Our post-post-postmodern time.

5. MASTER-BILT IM-38 OUTDOOR ICE MERCHANDISER

These things are everywhere, but I would argue that we don't notice them—until we need ice, that is—even though they stand in front of every grocery store and gas station. I remember noticing this version of the ice machine for the first time when I was back in college around 1989. I was writing my master's thesis and I was trying (unsuccessfully) to put forward this ice machine as an example of design that worked for its particular purpose.

That purpose includes signaling consumers driving by that the establishment sells ice. Beyond a signal, it keeps the ice frozen and allows for off-hour deliveries. Once the customer pays for the ice, it becomes a self-service device, operating on the honor system. But let's be honest: This ice machine is ugly, clunky, and awkward by any objective standard. The typography is generic and unconsidered. Note the difference in letterspacing and consistency of type size from the top to the front to the side. It's all the same vinyl lettering squeezed to fit each area to such a point that it doesn't look like it was designed at all.

But of course it was designed, and I argue, designed appropriately and effectively. The type is a blue (cold) sans serif (not a warmer typeface like Garamond). The boxes themselves are white (again, cold). The boxes look like big freezers, a place where ice would be found. They could make these things any shape, but someone chose this one.

In my experience, these ice machines are usually invisible. They don't appear to be designed to shout, "HEY, YOU NEED ICE!" Until I actually do. Then they are everywhere. Clunky, ugly, and appropriate to the purpose. Now, is that good or bad? Depends on whether or not you need ice.

DESIGNED BY PAUL SAHRE AND PETER AHLBERG

>> INTERVIEW: Ahn Sang-Soo
Seoul, South Korea

Seoul-based **Ahn Sang-Soo** is a respected and innovative designer whose work is recognized all over the world. An educator and design commentator, Sang-Soo has more than a dozen books to his credit and has won many prizes and awards. He has created four important Korean fonts that led the Korean Language Academy to commend him for the advancement of the Hangul, the native alphabet of the Korean language. He initiated the design education manifesto for ICOGRADA and is active in numerous international design organizations. Although he thinks deeply, when speaking in English Sang-Soo's language is economical and spare, almost lyrical in its brevity and directness.

PLEASE NAME SOMEONE WHOSE DESIGN WORK MAKES A HUGE IMPACT ON YOU AND YOUR COUNTRY.

King Sejong (or Sejong the Great) was king of what became modern-day Korea in the fifteenth century. He is a great designer whom I admire. He is credited with creating the first twenty-eight-letter Hangul alphabet. This is significant because the commoner had no Korean written language at the time. Chinese characters were used among the aristocracy, but the uneducated had no access to written language. Sejong felt that the Chinese written language has no ability to adapt and express Korean spoken language; therefore, in 1446 he introduced the first Hangul alphabet—it was easy to learn, but it was banned sixty years later. After World War II, it came back into widespread use. Today, twenty-four of the original twenty-eight forms are in use.

TWENTY-EIGHT-LETTER HANGUL ALPHABET DESIGNED BY KING SEJONG

"UNDER NONDECIPHERABLE TEXT
IS THIS UNBELIEVABLE SEASHORE.
THE DESIGNER EMPHASIZES A
NONUNDERSTANDABLE SITUATION
OFF THE SHORE OF THE KOREAN
PENINSULA. I AM ATTRACTED TO ITS
SENSE OF FANTASY AND WONDER."

Japan's grandmaster Sugiura Kohei is a wise designer. I feel his presence in all his work. An expert in Asian iconography, Kohei has five decades of work to his credit that spans the design gamut, with a lot concentrated in magazine and book design. His voice is singular and significant, strengthened by his writings on visual communication, music, and iconography in many books and papers.

"OF LESS VAULTED CONSIDERATION IS ONE CLOSER TO HOME. THIS LETTER WORK HANGS ON AHN SANG-SOO'S TOILET WALL. IT SHOWS WHAT LIFE IS: CHANGE, CHANGE, CHANGE... TURN, TURN, TURN."

"THE LIFESTRAW IS A POINT-OF-USE WATER FILTRATION AND WATER PURIFICATION TECHNOLOGY CREATED FOR USE IN DEVELOPING COUNTRIES. IT CAN FILTER UP TO SEVEN HUNDRED LITERS OF WATER (ENOUGH FOR ONE PERSON PER YEAR), COSTS ROUGHLY $3.00 USD (£2.06), AND KILLS 99.9 PERCENT OF HARMFUL MICROBES. THE LIFESTRAW IS GREAT DESIGN. WATER IS THE MOST FUNDAMENTAL ELEMENT OF LIFE."

LIFE PEACE LOGO

This logo (above) is significant. It speaks to our situation in life. The portion below is the human. To the right are lives with four legs. To the left are living things in the water and sky. Above, we view plants and trees. The human being is below because it must respect other life forms. A tree is on its head to serve as an antenna for receiving messages from the universe. Everything is linked. We are one; if an animal is sick, the human is sick. If they cannot live, we cannot live. If they are happy, we are happy. If all lives live in the right place in Oullim (great harmony in Korean), there is peace.

WHAT MOTIVATES YOU?
Happiness.

HOW DO YOU EVALUATE YOUR WORK AND THE WORK OF OTHERS?
My inner emotion. But one will wonder if I apply this to all designs. Well, I do. Good design comes from a state of concentration, "samadhi," and flow. Samadhi is preliminary to nirvana, in which there is consciousness of the self and all other objects cease to exist.

DO YOU HAVE ANY PROFESSIONAL ASPIRATIONS LEFT TO FULFILL?
In my life in design, I simply hope to find life... to find peace.

IN SUPPLYING SAMPLES OF HIS WORK, SANG-SOO SIMPLY INCLUDED THIS ARRANGEMENT OF POST-IT NOTES. AGAIN, FEW WORDS AND MUCH THOUGHT BEHIND THEM.

INTERVIEW: Rodrigo Cordova
Creative Director, Factor Tres
Mexico City, Mexico

Rodrigo Cordova of Mexico City is internationally recognized for his work on such famous brands as Nestlé, Bacardi, Colgate, and Pepsi, among many others. He arose from the first generation of graphic designers at La Salle University in Mexico City. Midway through his second decade as a professional, Cordova has gained the experience that gives him a degree of objectivity and perspective on what works—and what doesn't—when it comes to international design standards. Yet his relative vintage has not dimmed his passion for his work and trade. In conversation, Cordova radiates energy and gusto. If experience is his ballast stone, his intellect and talent fill his sails.

RODRIGO, PLEASE TELL US ABOUT A DESIGNER WHOSE WORK HAS INFORMED YOUR CAREER.

Vaughn Oliver is one. He used to be the principal designer at 4AD Records and later founded the 23 Envelope design firm. I first noticed his work on several album covers where he used arresting typefaces with duotone photographs. The guy could transmit a message using extraordinary technique and print production values such as metallic inks, duotone dyes and images, and spot varnishes. Two books I collected later that contain the largest volume of his work are called Visceral Pleasures and This Rimy River. They hold another clue to his success: stories about the relationships Vaughn had with many of the bands he worked with. His understanding of who and what they are is clear in his work. Other influences are designer friends Malena Gutierrez and Angel González, with whom I work.

TOP: VAUGHN OLIVER'S WORK FOR THE PIXIES

BELOW: SIMPLE AND UNIQUE: HORNALL/ANDERSON'S WORK FOR STARBUCKS AND WIDMER

You work a great deal with big brands. Is there a design group out there more like your own that you hold in high esteem?
Yes, the cross-disciplinary excellence long exhibited in the work of Hornall/Anderson Design of Seattle. Their work has always attracted me because they manage to define exactly what their clients need, make that their focus, and deliver in the final execution. The Starbucks identity is a good example, as is their package design for Widmer Beer. They achieve, in a simple and unique way, appropriate illustration and design to meet the client's need. Their work inspires good and effective design communication for big brands and corporations that is also highly creative.

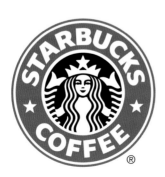

"WORK I FIND IN THE WORLD CHALLENGES ME TO EXCELLENCE, FROM CIDER TO WHERE LITERATURE MEETS ART IN *GRIFFIN AND SABINE*."

YOU MENTIONED THE CROSS-DISCIPLINARY SKILL OF HORNALL/ANDERSON. WHY DO YOU HOLD THAT UP AS A DETERMINANT OF GOOD DESIGN?
A designer who develops skills in other disciplines, such as illustration and editorial design, will find that it enriches and complements his or her work in many arenas. I have collaborated with architects visualizing spaces and with industrial designers on product development and I enjoy it very much. I must emphasize, however, that the ability to combine across disciplines is successful only with intuitive designers. Not everyone can do it.

WHAT KINDS OF EXTERNAL STIMULI INSPIRE YOUR WORK TODAY?
Everything. I absorb as much as I can from the visual world around me: clothes, furniture, labels, film credits, CD covers, websites, the supermarket, travel…Whenever I see good design I am challenged to achieve the same level of excellence. I want my designs to be just

JIM MOUSNER'S PASSION IS REFLECTED IN HIS WORK FOR SYSCO AND THE SAN JOSÉ CLINIC.

"GOOD DESIGN IS NOT JUST BUSINESS. IT CAN HELP A SOCIAL GOOD.
GOOD DESIGN IS NOT JUST ABOUT BEING SEEN AND NOTICED. IT
IS ABOUT TRANSMITTING FEELING, ABOUT ALLOWING THE OBSERVER
TO PARTICIPATE IN AN IDEA AND FEEL SOMETHING, TOO. I AM
FORTUNATE TO DO WHAT I LOVE. WHEN YOU DO THAT, YOU CAN CREATE
MANY THINGS."

as good. I also recommend that you take the time to find out something about the individual or company behind good work that you see. Learn something about their background, their life story. Understanding who they are as individuals reveals much more about their work. The glamour of appearing in a book and winning prizes tells us very little.

Whenever I meet another designer, I am like a sponge trying to absorb and learn as much about them as I can. I want to know how they see life. This is stimulating because the person you are is reflected in your design. Jim Mousner, for instance, whom I recently met, is much more than his prizes and fame. His passion for life is reflected in his work.

IS IT DIFFICULT TO EVALUATE GOOD DESIGN, TO SEPARATE THE GOOD
FROM THE BAD?

Good design must be practical, functional, one step forward, and satisfying to the client. These four principles guide my work. Living up to them is the challenge. And by satisfying the client, I mean you must always keep the planned objective in mind and evaluate the work against it. First, consider technique that is used, such as typography, photography, or illustration. Is the design meeting the objectives? Does it speak to its intended public? So much depends on the type of communication desired.

I also suggest that designers enter international competitions. It is a very good way to learn whether or not your work is considered good or even excellent internationally.

DO YOU HOLD ANY ASPIRATIONS BEYOND THE KIND OF WORK YOU ARE
DOING TODAY?

I am eclectic. I am influenced by other styles and tendencies and, while it may appear ambitious, I truly believe I am just now beginning to create my own style and voice. And that is linked to the principle: less is more.

"GOOD DESIGN MUST BE PRACTICAL, FUNCTIONAL, ONE STEP FORWARD, AND SATISFYING TO THE CLIENT. THESE FOUR PRINCIPLES GUIDE MY WORK. LIVING UP TO THEM IS THE CHALLENGE."

BE IT PACKAGING OR BOOK DESIGN, RODRIGO CORDOVA WORKS TO SERVE BOTH THE CLIENT AND HIS PASSION FOR DESIGN.

TETRA PAK

JOEL NAKAMURA

Without the gestalt of the actual wine bottle, it's hard to tell it is a wine product. I don't like how similar it looks to products my kids consume—the size, shape, and color. If this is for adults, it just seems wrong. Are we to drink wine with a straw? The typography is all over the place—big circus letters and a logo script. The product has no real identity. It's not doing anything for me.

MICHAEL HODGSON, PH.D

"Is this good design?" The answer lies in this one fact: You can ship the same amount of wine using one truck of Tetra Paks vs. twenty-five trucks of wine bottles. This is a *perfect* example of where design thinking needs to be as we look to our future.

EDUARDO BARRERA ARAMBARRI, NEUROGRAFISMOS

I'll take the cynical approach on this. It's only through nonserious communication that this wine can possibly have a positive impact. It appeals to a dark sense of humor, like mine.

Of course, glass wine bottles' perception will prevail as a symbol of finesse over a Tetra Pak, thus tagging its content as a better product. But perception can change over time. Maybe in three or four generations, or two or three if you drink enough.

I'd buy it once, just to show it to my friends and share the joke. But if the wine was good, I'd probably become a regular customer. The design definitely stands out and asks people to give it a try.

FUMI WATANABE, STARBUCKS

Although I love the romance that the bottle and cork embodies for wine, the Tetra Pak is a great solution. First, the Tetra Pak reduces the use of fossil fuels during shipping. It's lighter than bottles, and you can pack a lot in a small container because it doesn't break as easily as a glass bottle. Second, where no recycling is unavailable, it reduces waste.

I'd take the design further, so that the packaging is compost ready. I would look at how people drink the wine; do you really want to sip wine through a straw? Finding another way to access the wine would elevate the experience even more.

Where the romance of bottles and corks are not critical to the experience, this wine box is not a bad idea. Good design is smart for the environment. This proves it.

While certainly not eschewing other types of clients, **Elliot Strunk** of Fifth Letter is revered for championing good causes. Fifth Letter also has many design credits for Chronicle Books and various universities and corporations. Strunk quietly practices what many others only preach: putting his design skills and knowledge to good use in the interest of positive social change.

WHO IN THE WIDE GALAXY OF DESIGN STARS INFORMS YOUR WORK, ELLIOT? DO YOU COLLECT THINGS OF THEIRS OR OTHERS?

I gravitate toward designers who strike a balance between their own identifiable style and voice while crafting solutions that are unique for each client. Sharon Werner and Charles S. Anderson can do this. But I see fresh, young designers putting their thumbprint on the industry as well. For example, look at Threadless, a group of new faces who takes risks, has fun, and still meets the client's (or in this case the customer's) need.

I'm fascinated with things that transcend time because they are iconic and well designed. Among them, fruit crate labels, Legos, and packages like these matches and olives.

Designers should always strive to work outside the limits of their own discipline. After all, what are we if not curious problem solvers? Good designers take strategy, usability, and appropriateness into consideration along with beauty

"I'M FASCINATED WITH THINGS THAT TRANSCEND TIME BECAUSE THEY ARE ICONIC AND WELL DESIGNED. AMONG THEM, FRUIT CRATE LABELS, LEGOS, AND PACKAGES LIKE THESE MATCHES AND OLIVES."

and other aesthetic decisions, combining the elements into a wonderful whole. One fairly recent example is the story of Target's prescription medicine bottles and how the designer solved the common problem of nondescript medicine bottles in a very clever, elegant, and cost-effective way.

How do you know if a design is effective?

When clients and audiences ascribe value to your work. Did it raise awareness of a program for a nonprofit? Did it move product? Did the final execution meet the specific criteria, but remain pleasing to look at and enjoyable to engage with?

One of the reasons I get out of bed each day is that projects and audiences are a moving target. Tastes change, trends change, methods of communication change. I am constantly seeking ways to connect with clients and get them as excited as I am about design that connects with their audience. I ask myself, "What are new ways these challenges can

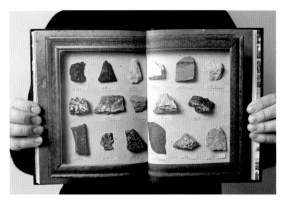

SHARON WERNER'S BROCHURES FOR CHARLES LUCK

WORKS FROM THREADLESS

manifest themselves visually and strategically?" I want to be able to outsmart the problem by discovering a unique and interesting solution that is appropriate for this single client at this point in time, to connect with this unique group of people.

WHAT ABOUT PRETTY? GOT A PLACE FOR THAT IN YOUR VALUE SYSTEM?
Yes. It's called an art gallery. I love beautiful design just as much as anyone—maybe more. However, the best design always informs. It tells me about the client's business. It shows me how to engage with a product. It helps me find a bathroom at a train station in a foreign country. So no, pretty pictures in and of themselves are art, not good design. Design solves problems. If a design fails to engage and inform the intended audience, it has failed, no matter how beautiful it is. A well-executed solution that is strategically appropriate is always one I enjoy. I may not be its intended audience, but I respect good design that effectively reaches its target. Obviously, plain vanilla solutions that are crafted to satisfy everyone always end up satisfying no one. I also believe that all passionate artists, regardless of discipline, look at everything they do and wish they had time for one last tweak.

I am rarely satisfied, even when my client is perfectly happy. When I see design work I really love, I get jealous because it's so smart, so perfect. I wish I'd done it. So I ask myself, if I saw one of our projects for the first time, would I wish we'd done it?

NAME ONE CHARACTERISTIC OF ANY GOOD DESIGN FIRM.
Consistency. The work of any well-respected design firm is always well crafted, fresh, timeless, and smart. It remains so even when the leadership of that firm changes, because they have established an internal culture that their employees understand and maintain.

IN WHAT WAYS CAN DESIGNERS IMPROVE THEIR WORK BY HELPING OTHERS?
Mentoring. I had internships and freelance jobs in college, and I have always felt the obligation to provide the same opportunities for other young people who are energetic, creative, and willing to focus their abilities in a constructive way. I also really like meeting many different types of people through my work, whether students, clients, suppliers, partners, or new friends. A person can't be in any type of business for very long before they realize that good communication and relationships are essential to success. And the value of these relationships is rich: They bleed into other areas of your life. The best clients for me are the ones I can sit across the table from in the day to share ideas and in the evening to share beer.

ELLIOT STRUNK WALKS THE WALK WITH WORK THAT IS MEMORABLE, MEANINGFUL, AND BENEFITS THE COMMON GOOD.

INTERVIEW: Scott Thares
Wink
Minneapolis, Minnesota, USA

Wink was founded by **Richard Boynton** and **Scott Thares** in 2000. Their work is always effective and memorable, often utilizing humor and exhibiting the founders' slightly off-kilter take on the world. To date, the Minneapolis-based firm has done work for such clients as Target, Nike, MTV, American Eagle Outfitters, Turner Classic Movies, Macy's, Medtronic, Toys"R"Us, PetSmart, Daub & Bauble, Blu Dot, Neiman Marcus, and the *New York Times*. Their versatility is impressive, with work that includes brand identities, packaging, print collateral, catalogs, posters, and environmental design. It is also widely recognized.

YOUR WORK HAS A DISTINCTIVE VOICE. IT USES A LOT OF HUMOR. YOU ARE VERY FUNNY. IS THERE A DOWNSIDE TO PUTTING YOUR OWN PERSONALITY INTO CLIENT WORK?

Humor can help attract attention and articulate a message. When appropriate, it appeals to certain audiences. We don't try to remove our personalities from the process. We communicate ideas visually with the same sensibility that we would verbally. Wink is very honest in this regard. We like clever, compelling, and witty. A lot of designers extol the virtues of some magical, proprietary process. Rather than telling people good design requires some proprietary process, tell them the truth: Processes are largely the same. Instead, arm yourself with knowledge. Arm yourself with as much information as you can get your hands on at the beginning of project. Dig in and find and gather as many creative resources and references relevant to the project as you can. Armed with that, you are prepared to create better solutions. But at the end of the day, it all comes down to the

"At the end of the day, it all comes down to the designers with the skills and experience who put themselves into the shoes of the intended audience—that's what people respond to."

designers with the skills and experience who put themselves into the shoes of the intended audience—that's what people respond to.

How would you evaluate successful design?
First, consider strength of the concept, the idea behind the design solution. Second, evaluate the quality and thought behind the actual execution of the solution. Finally, ask yourself if the two work in concert—does it answer the client's need? Does it work?

What kind of questions do you ask yourself when evaluating the quality or execution of a concept?
Is the final solution based upon a concept that solves the client's problem? Does it make sense to the audience—does it connect with them, does it resonate with them? Next, does the execution support the concept? Is it appropriate to the message? Will it resonate with the end audience? Finally, did the concept and execution work? Did the design solve the problem? If the most aesthetically pleasing airplane ever seen cannot take off or land, then it's an overdesigned, overpriced bus. It might be a beautiful bus—and a failed design.

Please name some designers and their work that elevate your thinking and inspire your work. Who are your heroes of great design?
Classically designed paperback covers from British culture, like these from Penguin, are so striking, so elegant, and the solutions are simply perfect.

WINK'S WORK FOR TARGET

Once you see how the stories are interpreted, it immediately makes you jealous by how simply the meaning is communicated. I am also a huge fan of illustrator Ben Shahn. His work is compassionate, satirical, humorous, and very human. When he puts pen to paper, he connects and evokes a deep human response. This is a rare quality. It is the kind of thing that distinguishes great work from the ordinary.

HAVE YOU SEEN ANYTHING RECENTLY THAT IS INSPIRING AND SIMPLE? When was the last time a political logo was so inspirational and so simply executed? The Barack Obama campaign dispenses with the usual clichés of red, white, and blue adorned with stars, stripes, and eagles, and boils the message of change and hope down to its essence. It says "change and hope" without the need for the cliché. The logo's design has been attributed to Chicago-based Sender LLC and mo/de. According to creative director Sol Sender, "We were looking at the *O* of [Obama's] name and had the idea of a rising Sun and a new day. The Sun rising over the horizon evoked a new sense of hope." Besides the quality of the logo concept and execution, I am a sucker for Gotham, and this campaign uses it beautifully.

The Shepard Fairey Hope poster will go down as one of the most memorable political posters in history.

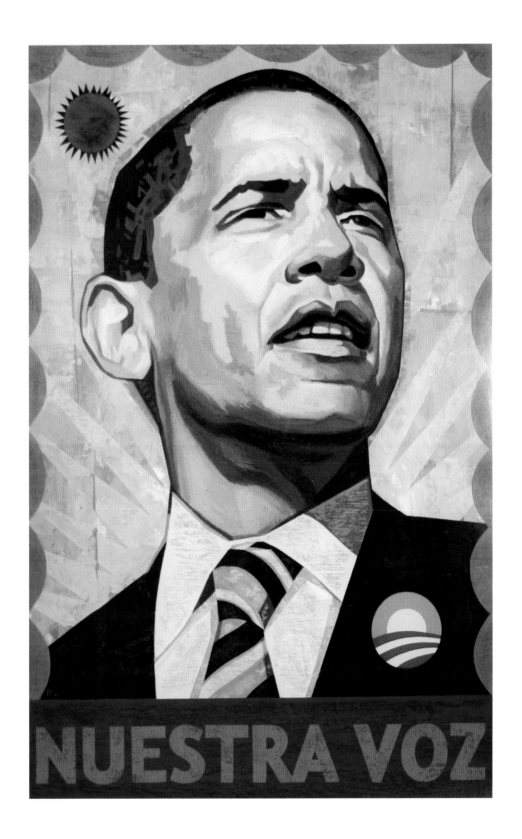

ABOVE AND OPPOSITE: WINK'S ANNOYINGLY GOOD WORK FOR TARGET, DAUB & BAUBLE, AND FOR FRIEND & JOHNSON ARTISTS REP

WONDER BAR

TIM HALE, FOSSIL

When design wasn't paying the bills, I subcontracted my skills as a jack-legged carpenter and assisted with interior remodels. The "pry bar," as we always referred to it, was an essential tool of the trade for dismantling cabinets or any previously constructed structure. The one flaw in most pry bars was that sometimes you had to place something under the long edge in order to get better leverage. With the Wonder Bar the designer has addressed this functional flaw by adding a half-circular bend in the long edge. It's genius! It's this type of practical innovation that improves the design of this tool. Sometimes, you actually have to use something before you find the deeper design solutions.

STEVE WATSON, TURNSTYLE STUDIO

This is good, if not great design. It boils form down to an absolute necessary essence in a very beautiful way. It's an iconic example of form following function. It is sculptural, with beautiful, feminine curves, while being tough as the Incredible Hulk. The asymmetrical shape looks good no matter which way it's oriented. The yellow end energizes the form and gives it a focal point. It is almost Swiss in its simplicity. I'm going to go buy one for my mantel.

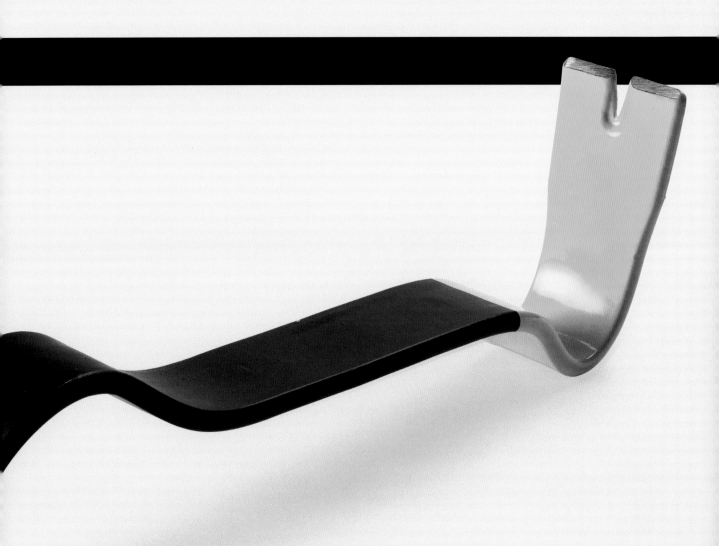

A BETTER DAY

Can design change the world? No. But *you* can, and having design skills can help you do it. Many of the people interviewed for this book allude to their work beyond for profit. For some, it is their principal source of joy and self-worth. For them, it is an opportunity to put their skills to work for something other than themselves and to exercise free expression. This kind of work is like soil, sunlight, and oxygen.

Our contributors remind us why designers are well qualified to help "change the world." They are strategic thinkers. They synthesize disparate ideas to create cohesive messages. They communicate ideas across the barriers of language, nationality, color, creed, and religion. They can connect emotionally and bridge divides.

But design is not *the* cause. Sustainability, voter registration, arts funding, and education are causes. You, not your trade, can be the change agent. Design is a tool—a feather or a crowbar, a kid glove or a sledgehammer. It is whatever you need to break through, get understood, and effect change.

No one used design for evil as effectively as Joseph Goebbels in the rise of Nazi power. Talk about cross-disciplinary skills. Talk about immortal. But do we hold his "success" in esteem—or do we keep it in mind as a symbol and a warning? The latter, I hope.

Will tomorrow be a better day? Only if you get up in the morning and work to make it one. As Bob Dylan wrote, "You gotta serve somebody...."

On Their Shelves

COLLECTIONS OF GREAT DESIGN

AIGA medalist and lifelong New Yorker, **Gail Anderson's** work in editorial and entertainment has been rocking audiences for nearly three decades. She works for SpotCo New York, an entertainment advertising agency. She teaches at the School of Visual Arts, her alma mater. After graduating in 1984, Anderson got her start with Vintage Books and then the *Boston Globe.* Anderson would gain widespread recognition at *Rolling Stone* working with co-AIGA medalist Fred Woodward, beginning as associate art director in 1987. She left the magazine in 2002. Anderson's work is broad and eclectic, characterized by the use of bold, innovative

typography, compelling illustration (which she has long championed), and photography. If good design is defined by the ability to connect with a specific audience on an emotional level, Anderson's is sheer mastery. She has been passionate about design all her life. As she told Steven Heller in a profile for AIGA's website, "I used to make little Jackson Five and Partridge Family magazines. I wondered then who designed *Spec*, *16*, and *Tiger Beat* in real life, and as I got older, I began to research what was then called commercial art." She made it her calling. Fans of great design are grateful she did.

So Gail, please share with us some examples of the kinds
of things that inspire and motivate you. What makes them
so compelling?

The Magic Castle was my first real book—mine—not one I shared with my sister, Gerry. She had *Cinderella;* equally lovely, of course, but *The Magic Castle* had drawings of children and candy. I was fascinated by the shape and taste (I chewed the corner), and the yellow plastic comb binding. And those drawings! Those children! It was all magic.

I loved *It's Like This, Cat.* The story was great—a kid in the city and his yellow tabby, a cat simply named Cat. I remember the black-and-white line drawings that I tried to copy in my notebooks and the nonchalant voice of the young boy. This was a cool middle-class city-kid book that made me feel like a teenager, even though I must have been in third grade when I read it. The design still sticks in my mind more than thirty years later.

My mother worked at the Salvation Army in Mount Vernon, New York, so all of the books on my high school reading list came from its shelves. Why spend the money when you can get them for a quarter, right? At the time, I didn't quite get it. I was a little embarrassed by the ancient covers on my copies of the classic paperbacks, but soon realized those covers

were far superior to their late-1970s counterparts. The *Death Be Not Proud* and Anne Frank covers were heart-breaking in their simplicity, and the painting on the *1984* cover was, well, just cool.

I was all about *Mad* magazine in the late 1960s and '70s. I was probably too young to really get the subversive humor, but it was still really, really funny to me. I folded the inside cover accordion-style to get the secret joke at the end of each issue, and chuckled over the movie and TV spoofs. I wasn't a fan of *Spy vs. Spy*, but I did love those little cartoons along the gutters and all that silly Don Martin stuff. The layouts were complex and rendered with great attention to detail, and I wanted to be a real wise guy like all those *Mad* cartoonists, "the usual gang of idiots." Magazines started to become a real addiction for me with *Mad*.

As I entered my preteen years, I subscribed to *Spec* and *16*, and began to wonder how I could get a job doing that. They used all those Chartpak rules and lots and lots of Letraset typefaces, and there were loud colors everywhere. I marveled at cutout heads and crazy silhouettes of Michael Jackson's Afro and decided, once and for all, that I wanted to be a commercial artist, whatever that was. It sort of made perfect sense that I ended up at *Rolling Stone* for fourteen years after my *16* and *Spec* phase.

My parents had lots of LPs and a huge record player with tubes and dials. Even the speakers were cool, though the cat used them as a scratching post. It was the 1960s and everything was cool, I guess. Album covers were just fascinating to me, and though my personal taste leaned more toward the Partridge Family, I thought my folks had the best-looking record collection going. The painting on the Nat King Cole *Songs for Two in Love* cover still makes me weepy, even today. That couple was really in love. And the Harry Belafonte and Ray Charles covers actually made me want to put those records on the turntable—so I did. The power of graphic design. Now, as an adult, that's the music that stays with me, though I do still love a little Partridge Family from time to time. As I grew older, I began to design like the covers of my teen years; all that new-wave B-52's and ska stuff formed the aesthetic of my early art school design projects.

I was a big bottle-cap collector for a few years and amassed a collection of over four hundred crowns. That's actually a minor league collection by serious collector standards, but it was certainly fun. I started shooting my caps, and ended up traveling to the south to shoot other people's collections. I even attended Crownvention (the bottle-cap collectors' convention) twice. Then I slipped on one of my caps and ended up on crutches after knee surgery. My love affair with the crown was over.

The thing is, though, that bottle caps are beautiful. The old designs on the cork-backed ones (pre-1980) were spectacular, and some of the rare ones can fetch some pretty big bucks. I got into collecting bowls and shelves and other stuff made of caps, and have a row of bottle-cap men above my kitchen cabinets. There's lots of interesting tramp art made of crowns, and crazy stuff like jewelry and handbags. So when you think about it, the bottle cap is a pretty perfect design. It's utilitarian but can be as gorgeous as a poster when someone puts a little love into the graphics. Just don't leave any lying around on the floor.

YOU ARE INSPIRED BY MANY THINGS. YOUR WORK INSPIRES MANY PEOPLE. WHAT ARE SOME OF YOUR PERSONAL MOTIVATIONS?

I am motivated by fear and deadlines. I dread starting a project for fear of screwing it up or coming up dry, but can get my juices going as the fear of the upcoming deadline approaches. Every now and then, I get really jazzed about design when I'm teaching or just from looking at a book or website. Good music still does it for me almost better than anything else. I go into a design trance and forget about everything else that's falling apart all around.

WHAT DOES GOOD DESIGN ENCOMPASS?

I try to evaluate my work on its ability to make an emotional promise. Does it nudge the ticket buyer towards making a purchase? I know that realistically there's only so much that the key art for a show can do: It's about the stars, the plot, the buzz. But what are we telling the consumer as she glances at the marquee or at the ad in the paper? What kind of promise are we making? What kind of night are we promising? Those are the kinds of connections good design should be making. Of course, in the end, I want the art to look great and to feel fresh; that's a given—but I know that the goal is to sell tickets. I want the final solution to look easy and not labored. I want others to see it and think, "Of course—that's the only solution!"

DO YOU USE THE SAME CRITERIA WHEN EVALUATING THE DESIGN WORK OF OTHERS?

The dud designs always reek of perspiration, like they were working way too hard. But, generally, I am much more forgiving of other people's work as long as they're using the right apostrophe and quotation marks. I'm easy.

DO YOU HAVE AN AESTHETIC TO WHICH YOU ASPIRE OR LOOK UP TO?

I would like to have as delicate a hand with type as Louise Fili. Period. But my volume is always turned up way too high to have that kind of restraint, even when given the right kind of project. I look at her work and just sigh. And it doesn't get any better than the work of Paula Scher, either. Read her book *Make It Bigger* and you'll learn everything you need to know about graphic design.

AT THE END OF YOUR LONG CAREER, WHAT DO YOU HOPE TO HAVE ACCOMPLISHED?

I'd like to do something that doesn't get thrown away. I think that's part of what keeps me going with my book projects with Steve Heller. Magazines become fish wrap. Shows close. But books have shelf life, so to speak.

GAIL ANDERSON'S ABILITY TO INJECT SOUL INTO NOT ONLY HER WORK BUT EVEN HER USE OF TYPE IS ONE OF THE REASONS HER WORK IS TYPICALLY GOOD...AND THEN SOME.

Tim Hale

Fossil

Dallas, Texas, USA

Motivated by desire to grow as a designer, **Tim Hale** moved to Dallas in 1985 from his native town sixty miles north and started an in-house design and production studio for an embroidery specialty manufacturer. In 1987, Tim joined Fossil to start and head up the in-house design department. The relationship that followed is a success story on many fronts. Hale is a frequent speaker, and his work has appeared in publications such as *CA, Print, How, Graphis*, the *AR 100, Graphic Design, USA*, and *Step Inside Design* magazine. He shares his expertise by serving as a juror for the ID Magazine Design Annual, Type Directors Club, and the Communication Arts Magazine Design Annual. Hale's packaging work has been selected for inclusion in the permanent collection of the Museum of Architecture and Design in Chicago.

TIM, PLEASE SHARE SOME EXAMPLES OF ITEMS YOU CONSIDER GREAT DESIGN. TELL US WHY THESE SELECTIONS ARE SO COMPELLING TO YOU.
My earliest recollection of anything resembling design was Rat Fink by Ed Roth. I used to collect the cards, the posters, the models, and anything else I could lay my hands on. The freedom of expression that seemed to flow through the irreverent car and cycle humor completely captured my youthful imagination and encouraged me to attempt to draw and develop as an artist. It was also my first recollection of anything resembling typographic illustration. It was through some of my early attempts that I discovered that I could draw. I used to illustrate comic hot rods up into my high school days.

RAT FINK TRADING CARDS BY ED ROTH

In my latent years of elementary school, sixth grade as I recall, I became enamored with the art and illustration of Peter Max. I am sure this was related to my older sister bringing *Yellow Submarine* into our home. I really don't remember the initial encounter, but I do remember spending hours with a box of oil pastels re-creating his work on large pieces of Bristol paper from a book of his illustrations that my mother bought for me. I think that probably began my commercial tendencies; as I began to reproduce them and sell them to my classmates; I realized that I could get paid for doing art. Sorry, Peter.

I was heavily involved in music, so music was a big influence in my youth as well. Though I grew up on country music in the typical, Friday-night lights, northern Texas town of Sherman, I discovered rock

1960S PETER MAX ILLUSTRATION ON THE BEATLES' YELLOW SUBMARINE ALBUM

EAGLES GREATEST HITS:
ELEKTRA RECORDS, 1976
AD & DESIGN: BOYD ELDER, GLEN CHRISTENSEN
PHOTOGRAPHY: TOM KELLY, JR.

BOSTON:
EPIC, EPIC 1976
AD: PAULA SCHER
LOGO DESIGN: GERARD HUERTA
ILLUSTRATION: ROGER HUYSSEN

CHICAGO GREATEST HITS:
FULLMOON/REPRISE RECORDS, 1989
AD: JANET LEVINSON
LOGOMARK: NICHOLAS FASCIANO

JOURNEY GREATEST HITS:
COLUMBIA RECORDS, 1988
DESIGN: STANLEY MOUSE, MOUSE STUDIOS

and roll due to my fascination with 1970s album cover art and my participation in a '50s rock cover band called the *Chrome Fenders*. Due to this association, I was a big fan of the *American Graffiti* cover art—or maybe it was the illustrated carhop girl on roller skates, but hey, I was fifteen.

The typography and illustration on the covers of the *Eagles*, *Chicago*, *Boston*, and *Journey* albums really inspired me even more to pursue commercial art as a career. Some artists somewhere were having way too much fun and getting paid for it.

Looking back, my first recollection of design and typography images were designed without the benefit of anything resembling a computer. It was all analog, stop-frame animation with handcrafted graphics and typography that was usually crafted with a brush. TV was coming of age in the '60s, and the sitcom serials of the day utilized beautiful and entertaining title panes that I can still recall today. That style and craft stuck with me all the way into college, where I would have the opportunity to learn the fundamentals of brush lettering and illustrating type utilizing French curves, a T square, triangles, and Rapidograph pens. The earliest work in my career employed those tools, and it seems fitting that in many circles that craft is returning to our trade today, as current designers discover that some of the most distinguishing work is still done by hand.

TV SERIES TITLES: *THE ADDAMS FAMILY, MY THREE SONS, BEWITCHED, I DREAM OF JEANNIE*

"TV WAS COMING OF AGE IN THE '60S, AND THE SITCOM SERIALS OF THE DAY UTILIZED BEAUTIFUL AND ENTERTAINING TITLE PANES THAT I CAN STILL RECALL TODAY. THAT STYLE AND CRAFT STUCK WITH ME ALL THE WAY INTO COLLEGE, WHERE I WOULD HAVE THE OPPORTUNITY TO LEARN THE FUNDAMENTALS OF BRUSH LETTERING AND ILLUSTRATING TYPE UTILIZING FRENCH CURVES, A TSQUARE, TRIANGLES, AND RAPIDOGRAPH PENS."

YOU ARE INSPIRED BY MANY THINGS. YOUR WORK INSPIRES MANY PEOPLE. WHAT ARE SOME OF YOUR PERSONAL MOTIVATIONS?

I am perpetually dissatisfied, largely, with my own abilities and myself. I have always said that I am not the most talented, I am just willing to work harder at it to compensate. I have observed in my own work and in the work of others that sweat equity goes a long way in compensating lulls in creativity. In creativity, contentment can be a curse that lulls you into a false sense that you actually accomplished something. There is always another level or another technique or another medium that I would like to reach a certain level of accomplishment mastering, and there is a finite amount of time to achieve it.

DO YOU HAVE AN AESTHETIC THAT YOU ASPIRE TO?

I would like to have the discriminating eye of Paul Rand, the type skill and imagination of Fred Woodward, and the illustration skills of Mike Giant and Bart Forbes. Truth be known, I would like to retire airbrushing and pinstriping, or take the high road and teach at the college level.

AT THE END OF YOUR CAREER, WHAT DO YOU HOPE TO HAVE ACCOMPLISHED?

I realized early in my career that everything I was doing had a very transient value and that, for the most part, a single match could make short work of my life's work, so I am glad I produced some of my work on tin. But seriously, there is a very famous book that tells us that life is like vapor: here today, gone tomorrow. That gives me a different perspective on what I hope my work is really about, and that is engaging with other designers whom I have had the pleasure to coach and work with throughout my life. I hope that whatever I have done added some value to their life and work.

Marc English
Marc English Design
Austin, Texas, USA

Austin-based designer and educator **Marc English** calls himself a shaman. He collects ideas and artifacts of his travels. He puts down almost everything and every name he encounters in a little leather-bound journal. One day, someone is going to discover these journals at a yard sale and publish them, if English never gets around to it. Beyond a collector, English is a showman with lots of talent and interests. Although he came to Austin by way of Boston, he seems most comfortable on the road. If you ever meet him, ask him to show you his journal—it is a lifetime achievement, a passport stamped with experiences and expectations, triumphs and disappointments. English's profession might be design. But his gift is accumulating experiences and bringing those alive through his work. "Frontiers are where you find them," he says.

YOU COLLECT AND READ A LOT. NAME SOME OF YOUR FAVORITE SCRIBES.
The late writer Guy Davenport once wrote, "Man, it would seem, does not evolve; he accumulates." Nothing I have ever designed has been new. I have gathered and accumulated even before I knew what the word design meant. He also said, "Knowledge is the harvest of attention. Awareness is an event caused by multiple forces, setting multiple forces in action. No force is ever spent. All events are lessons. No event can be isolated." Good design opens the mind. It causes awareness.

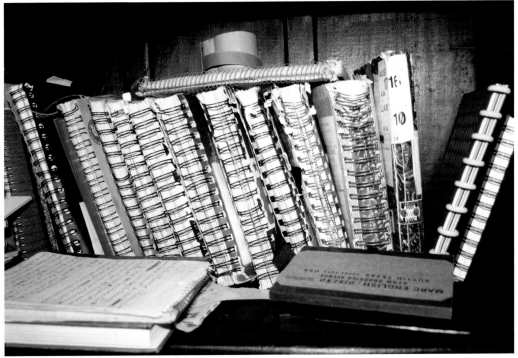

ANYONE WHO HAS EVER BEEN IN YOUR OFFICE KNOWS THAT IT LOOKS LIKE THE CRAZY AUNT'S ATTIC. YOU HAVE FUN AND AMUSING SIGNS, CANS, BELTS, TOYS, POSTERS EVERYWHERE. IS THERE ANYTHING OR ANYONE WHO DOES NOT INTEREST YOU?

Everyone and everybody I have encountered who has sharpened my awareness and insight. This includes scientists, mathematicians, antiquarians, poets, artists, designers, and explorers of every kind. They see the weather, smell the richness in things, and reveal the connection to life, where others see only facts. Poets do this—they allow the reader to taste, hear, touch, and smell. Good design is like poetry. It connects facts to our lives, to our humanity. It reveals like the rising Sun at dawn, or like a window shade that suddenly opens.

WOW. I'M GETTING A LITTLE DIZZY IN HERE. MIND IF I OPEN A WINDOW?

Exactly. Good design forces you to open a window—to look beyond the limits of your room.

David Kampa of Austin is a great. Why? Because he's rarely satisfied. He exercises a level of detail and craftsmanship that is welcome but rare.

When I first saw this cover by Paul Rand, I was in my postpunk, precowboy days. Its visceral layout compelled me, while its simplicity allowed it to endure, investing it with meaning, metaphor, and history that was relevant forty-plus years later.

Then it gets personal. There's a little tag that looks to be attached by a red string, a handwritten note saying "Merry Christmas," along with issue number and date with a few little asterisks or snowflakes suggesting a New England white Christmas.

Why use barbed wire to wrap a Christmas gift? To remind the viewer that Christ died on the cross? Aren't we supposed to be celebrating his birth, not his death? Note the date. Now you can understand the historical context. The Second World War was underway. The United States would enter exactly one year later. This is a simple execution—and it leaves a lot to the viewer's imagination.

ABOVE: ENGLISH'S OFFICE IS FILLED WITH EPHEMERA FROM EVERYWHERE.

OPPOSITE TOP: SHINER BLACK LAGER, DESIGNED BY DAVID KAMPA

OPPOSITE BOTTOM: *DIRECTION* MAGAZINE COVER, 1940, DESIGNED BY PAUL RAND

MARC, EVERYONE KNOWS YOU CROSS-DRESS IN YOUR MUSICAL ACT FROM TIME TO TIME. BUT DO YOU CROSS DISCIPLINES IN YOUR COLLECTIBLE ZEAL, TOO?

Design is a thought process that can lead to an artifact. It involves research, analysis, and implementation. Designers every day span supposed limitations just as others do in many fields of study. I am motivated by intersections and the great beyond. I have a great curiosity for people, places, cultures, music, language, food, geography, art, and many other things. What's over the next ridge? What's around that corner?

YOU JUDGE A LOT OF DESIGN COMPETITIONS. HOW DO YOU PICK AND CHOOSE BETWEEN THE GOOD AND THE GREAT?

Context, partner. Some design is meant to challenge. Some design is intended to be easily and quickly ingested. The former involves thought and reason; the latter involves baser instincts. Each addresses a specific need. Sometimes, they even overlap. If the work achieves its purpose—if it achieves a goal, answers a need, connects with the intended audience—then it can be objectively considered successful. That does not mean it is also beautiful, memorable, facile, or even especially attractive. It just means it did its job.

YOU ALSO TEACH A LOT. HOW DO YOU CRITIQUE STUDENT ASSIGNMENTS?

Here are the five criteria that I apply to student work: concept, design (i.e., layout), typography, color, and craft. What often fails first is typography, followed quickly by layout and color. Assessing concept is most difficult, especially if all of the above appear competent or even superb. Sometimes layout, typography, color, and craft can be fairy dust, blinding you to a weak concept. On the AIGA medal (designed by James Earl Fraser in 1920) are the words Utility and Beauty. I might say "appropriate and unique." Communication design needs to have a purpose and be appropriate to the message, medium, and audience.

WHAT'S LEFT? YOU ARE ON THE MOUNTAINTOP. GOT ANY ASPIRATIONS LEFT?

Oh, please. I aspire to pay the rent this month. Seriously, do I have an ultimate version of "all things worldly" in mind? Yes. Do I aspire to it? Only in the abstract. I've never sought anything more than to do good work. In the process of trying to achieve that goal, I am pleased to discover that some of my efforts have inspired others, and knowing that gives me a degree of satisfaction. I do not wish to make the world in my image. I do not aspire to be the ultimate designer. I would be lying if I said I did not love both for the perspectives they add, but perspectives can only be shared when you come down off the mountain to where most of us live. It's cold and lonely at the top of a mountain.

MARC ENGLISH'S INTERPRETATION OF *MY OWN PRIVATE IDAHO* FOR THE CRITERION COLLECTION DVD BOX SET

INTERVIEW: Sean Adams
Partner, AdamsMorioka
Beverly Hills, California, USA

AdamsMorioka is on a mission. In 1994, **Sean Adams** and his partner, **Noreen Morioka,** founded AdamsMorioka and have aspired ever since to bring a little more joy and levity to design. Their philosophical approach of clarity, purity, and resonance immediately hit a hot spot in the design world that was, at the time, about excess, complexity, and oblique communication. AdamsMorioka's work is deceivingly simple: Complex ideas and strategic planning are typically integrated into forms that are optimistic, vibrant, and easily accessible. Now, their philosophy is integrated into design mainstream. Adams is driven to public service. Be it nature or nurture (he descends from a long line of public servants), he sees his teaching at Art Center College of Design, lecturing, and promoting the design community as president of AIGA, as giving back. In addition to projects for high-profile clients with AdamsMorioka, he also juries shows, authors books, and writes a monthly column for *Step* magazine. Adams is considered one of the forty most important people shaping design internationally by the ID40.

SEAN, YOU ARE KNOWN FOR YOUR GOOD TASTE AND COLLECTIONS. WHAT KIND OF THINGS DO YOU LIKE TO COLLECT AND WHY?
Adlai Stevenson was my grandmother's cousin, and I found this poster in a closet at her house when I was in high school. It was on my bedroom wall along with endless sailing pictures. Not only does it hold sentimental value to me, it was a constant source of inspiration. I'm ashamed to admit how many high school homecoming posters I designed using the same forms and type of photograph.

STEVENSON FOR PRESIDENT

ROBERT ROOT

This poster works for me because it is so direct. There are no frilly eagles with ribbons, or conventional American flag images, or even the standard, all-capital-letter Caslon typography. It's modern and minimal, optimistic and forward-looking, and easy to read. I also love that it does such a great job of working against Stevenson's negatives, that he was elitist or too intellectual. He seems friendly and approachable, and unlike most of the current election communications, real.

This dish towel is pink, it has a riverboat, and it has some cute type; what's not to love? Why does a dish towel need to be beige, or bland, or sad? This is a useful everyday item that does its job with joy and levity. It's almost too wonderful to use, but that's the beauty of modernist thinking here: Good design can be reproduced and make the lives of the masses better. There is obviously a nostalgic element in this, and I like that it was produced with the same intention of nostalgia in 1955. The elements and iconography talk about an idealized America in the nineteenth century. It was pertinent to people during the Eisenhower years, and maybe I'm trapped there, but it works for me, too.

When I try to determine what things I think are well designed, I invariably fall back to objects that are joyous. Sure, an OXO spatula is great, but it doesn't have the same emotional resonance for me as the 1971 Walt Disney World map. First, how do you make a map that is easy to understand, works with three-dimensional easy-to-understand buildings, and covers hundreds of acres? This map does these things simply and clearly, and it's

WALT DISNEY WORLD MAP

playful and gives the sense of adventure and incredible places to be explored. Maybe the design value of an object can be determined by the response it evokes from the final user. It's hard to look at this optimistic and uplifting piece of functional design and not smile, even if you're jaded and cynical and do it on the inside.

After the Northridge earthquake in 1994, when all of the Russell Wright dinnerware shot across the kitchen and broke, I switched to plastic dinnerware. It seemed like a logical step. I found a set of Melmac plates that had never been opened, and after I started to use them I couldn't understand why anyone would ever use china again. Of course, my mother would say it's because other people have good taste and enjoy eating on something that doesn't bounce in the sink. Nevertheless, I find them to be incredibly functional, easy to clean, unbreakable, and beautiful. I have to admit, I've become something of an aficionado of plastics. I stay away from the post-1960s models; they tended to simply try to replicate the look of china with traditional patterns. I like the sets that are blatantly plastic and are

in colors or forms that can only exist in plastic. And there is true joy in asking a refined famous designer if they don't mind having their cocktail in a plastic mug.

WHAT INSPIRES AND MOTIVATES YOUR WORK?

I don't think the question here is about inspiration; that's a different idea. To lay it on the line, simply and honestly, I am motivated by security. I want the world and my life to be safe and productive. Obviously, there are other factors that motivate me: creativity, working with others, building a life. I am most excited by a project when I know it will involve the need to provide reassurance to the viewer. I may be criticized for using nostalgic forms, but I believe there is a way to use nostalgia, or the memory of an idealized past, without falling into sentimentality. This is the welcome mat, the friendly front door of any piece. Once inside, the message can be complex, or contradictory, or disturbing, but it is the sense that "this is a safe place to go" that seduces the viewer into doing something.

"I FOUND A SET OF MELMAC PLATES THAT HAD NEVER BEEN OPENED, AND AFTER I STARTED TO USE THEM I COULDN'T UNDERSTAND WHY ANYONE WOULD EVER USE CHINA AGAIN. . . . I FIND THEM TO BE INCREDIBLY FUNCTIONAL, EASY TO CLEAN, UNBREAKABLE, AND BEAUTIFUL."

HOW DO YOU KNOW IF IT'S GOOD?

The first point that we look at is whether it will cause an action. Will it drive viewers to change their opinion, buy a product, and reconsider their options? If it doesn't, regardless of how successful the aesthetic choices are, it's a failure. But simply driving a viewer to action isn't enough. You can do that by yelling "Fire!" in a crowded theater. It must also be crafted with the utmost care and attention to detail. The images, typography, and structure must be well considered. And each piece should talk to the viewer with respect and intelligence. If we make something that feels self-important or condescending in any way, then we are being the worst kind of communicator and taking a stance that is elitist and exclusive.

AND WHEN YOU EVALUATE THE WORK OF OTHERS, HOW DO YOU DECIDE IF IT IS GOOD OR BAD?

When I'm judging a competition, I'm looking at the craft issues: production quality, typography, images, and materials. And I'm looking at concept. Is there one? Can I understand it? I'm certainly more generous with other designers' work than mine. Each person has

...for mother

...because she's always wanted dinnerware
that's beautiful and guaranteed
break-resistant, too!

for the bride...

...because Melmac dinnerware is so smart,
so colorful, so carefree to use
she'll enjoy it happily ever after!

...for yourself

...because you want dinnerware that sets
lovely tables for your important dinners
and brightens up your everyday meals, too!

MELMAC®
dinnerware

Melmac quality melamine dinnerware
is guaranteed by its molders for a full year
against breaking, cracking and chipping.

Melmac is quality molded dinnerware
but not all molded dinnerware is Melmac.

Melmac is found in leading stores
under individual molder's brand names.

Look for the Melmac tag.

MELMAC
quality melamine
dinnerware

CYANAMID

Melmac is the registered trade-mark of American Cyanamid
Company, New York 20, N. Y., supplier of molding com-
pounds to manufacturers of quality melamine dinnerware.

RAFFIAWARE CUPS

"WE WANT THE WORLD TO BE A LITTLE MORE JOYOUS AND TO KEEP LEVITY AND A SENSE OF THE PLAYFUL IN THE DESIGN WORLD."

a unique experience, a wealth of life stories and memories. That's what makes design so compelling: The same idea can be articulated a million ways. It will always be different for every designer, so I'm willing to allow for individual choices that are different than mine. Although I can't get past things like bold serif fonts or work that is purposefully oblique.

NAME A DESIGNER WHOSE AESTHETIC YOU TRULY LOOK UP TO.

I start every project with the hope that I can do something as restrained, elegant, and sublime as Michael Vanderbyl. The first sketches start out in the right direction—classical forms, white space, black-and-white palettes—but then a strange detour happens. Perhaps it's because I'm not Michael, but the white space soon looks better as a solid yellow, and the black-and-white palette shifts to fluorescents. I'm okay at keeping the type restrained, and in the end, the piece looks like I did it. Which makes sense, since I did.

YOU'VE ACCOMPLISHED SO MUCH IN THE DESIGN WORLD. AT THE END OF YOUR CAREER, WHAT DO YOU WANT THE OBIT TO SAY ABOUT YOU AND YOUR WORK?

How macabre! But I am on a mission. No joke. We want the world to be a little more joyous and to keep levity and a sense of the playful in the design world. I certainly don't want to see the AdamsMorioka look on everything; that would be like being trapped in It's a Small World. But I wouldn't want design to slip into being so self-important that it sinks under its own gravity. And there's no choice here; I want to know I was able to help someone along, either by working with AIGA and serving the entire community, or by teaching and giving an insight to a student, or by doing a lecture and giving a little inspiration to someone who feels a little down. My family has been in public service in this country for four hundred years. Maybe it's genetic, but I can't imagine a life without giving back. That would be very dull.

RECYCLED SHOPPING BAG

ULHAS MOSES, UMS

What a nice use of waste material. They are made of old banners, which create accidental imagery when assembled into a bag. This brings new meaning, abstract color, and shapes. One may never guess these bags originated from recycled materials.

TIM HALE, FOSSIL

I find the recycled bag to be an intriguing and brilliant concept, especially now that global audiences are more attuned to socially conscious design that provides practical solutions that also reduce waste. Oh, yeah, and they look cool, too!

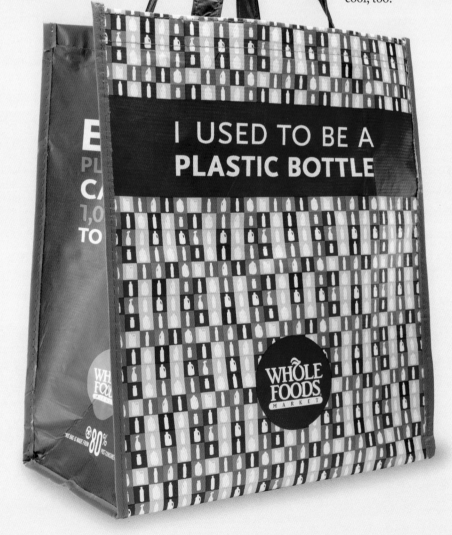

I USED TO BE A **PLASTIC BOTTLE**

WHOLE FOODS MARKET

TELL ME A STORY

Everyone loves a good story. We gather around campfires to hear them. We curl up with good books to read them. We go to the movies and tune in to TV to watch them. Tell me a good story, and I'm entertained, informed, startled, amazed, inspired, surprised, shocked, or warned.

Good design tells a story. The key is to make design a vehicle for the story. Design can compensate for bad writing by eliminating the need for confusing words. It can create the emotional connection needed to tell the story. It can connect through shape, image, and color when words cannot. It can lend texture and depth to the narrative. It can compel the reader to turn the page. It can reward persistence and concentration.

All good stories don't need pictures. But all good design does need a story. How well we "tell" it is up to us.

Contributors

SEAN ADAMS
AdamsMorioka
adamsmorioka.com

GAIL ANDERSON
Spotco
spotnyc.com

EDUARDO BARRERA ARAMBARRI
Neurografismos
neurografismos.net

MATTEO BOLOGNA
Mucca Design
muccadesign.com

ART CHANTRY
Art Chantry
artchantry.com

RODRIGO CORDOVA
Factor Tres
ampersandgcw.com

MARC ENGLISH
Marc English Design
marcenglishdesign.com

SANDRA EQUIHUA
Fulanita
fulanita.com

STANLEY HAINSWORTH
Tether
tetherinc.com

TIM HALE
Turnstyle studio
turnstylestudio.com

JOSH HIGGINS
Josh Higgins
joshhiggins.com

KIT HINRICHS
Pentagram San Francisco
pentagram.com

MICHAEL HODGSON
Ph.D
phdla.com

NICK JONES
Browns Design
brownsdesign.com

ATSUKI KIKUCHI

Bluemark

bluemark.co.jp

ENSI MOFASSER

Ensi Mofasser

CLEMENT MOK

Clement Mok

clementmok.com

ULHAS MOSES

UMS

umsdesign.com

JOEL NAKAMURA

Joel Nakamura

joelnakamura.com

HENRIK PERSSON

Henrik Persson

ROBYNNE RAYE

Modern Dog Design

moderndog.com

PAUL SAHRE

Office of Paul Sahre

paulsahre.com

AHN SANG-SOO

Ahn Sang-soo

ssahn.com

ELLIOT STRUNK

Fifth Letter

fifth-letter.com

SCOTT THARES

Wink

wink-mpls.com

FUMI WATANABE

Starbucks Global Creative

starbucks.com

STEVE WATSON

Turnstyle studio

turnstylestudio.com

Index

About the Authors

Terry Marks is a graphic designer living in Seattle, Washington. This is his second book for Rockport Publishers. His firm, tmarks design, affords him the opportunity to earn a living and search out what it is to do meaningful work. He lives a happy life in the shire with his wife and daughter, Ava Gene. www.tmarksdesign.com

Matthew Porter is a writer, critic and creative consultant who lives in Atlanta, Georgia, with his partner of 13 years. He attended college at Georgetown University where he graduated cum laude in 1985. After a fellowship at the Poynter Institute in St. Petersburg, Florida, he began a career that has included magazine writing, public relations, design and advertising. In addition to Atlanta and Washington D.C., Matthew has worked in New York, Los Angeles, Bangkok, and San Francisco. He is a regular contributor to *Communication Arts* and *Step Inside Design*. He opened PorterWrite in 1997. www.porterwrite.com